ペンとカラーインクで描く

INTRODUCTION TO

DRAWING WITH

PEN AND COLOR INK

INTRODUCTION TO
DRAWING WITH PEN AND COLOR INK

by TORINO MASARU ITTETSU NARITA©
Copyright © 1993 by Graphic-sha Publishing Co., Ltd.
1-9-12, Kudan-kita, Chiyoda-ku Tokyo 102 Japan

ISBN4-7661-0715-2

Printed in Japan
First Printing, July 1993

目次

CONTENTS

翻訳　フルー・ギャビン
レイアウト　株式会社エイジ
撮影　今井康夫

Translation by Gavin Frew
Layout by AGE.KK
Photograqh by Yasuo Imai

はじめに

Foreword

　ペンと黒インクによる線描や点描は代表的な技法だが，筆圧や筆勢，タッチを変えることで表現の幅は広がる。それに液状に凝縮された透明水彩絵具ともいわれるカラーインクを併用して表現の幅をさらに広げてみよう。本書は絵画やイラストレーションの分野に活用できるように，モノクロームのペン画から鮮やかなカラーの世界まで技法のすべてをとりあげた。

ForewordThe basic techniques in monochrome pen and ink drawing comprise of lines and dots but interest can be created in the expression through variation of the pressure and vigor of the strokes. Again, the use of color inks, which are sometimes referred to as liquid transparent watercolors, enlarge the scope of this field enormously. This book covers all the techniques needed to express everything from monochrome pen and ink drawings to the vivid world of color and allows you to create both serious pictures and comical illustrations.

1　章
ペンと黒インクの扱い方

Chapter 1
Using Pen and Black Ink

ペンの種類
Types of Pens

つけペン

ペン画の線や点の濃度はインクと同じである。鋼鉄製のペンは弾力があるので，筆圧の強弱で変化のある線が引けるのが特徴。いろいろな形があり，その先端の形で線は微妙に異なる。丸ペン，Gペン，かぶらペンがあれば十分。

Pen Nibs

The density of the lines and dots in a pen and ink drawing is dependent on the ink used. The main characteristic of steel nibs is that they have a certain amount of flexibility which may be used to create variation in the pressure of the lines drawn. There are numerous types available and the shape of the tip produces subtle changes in the lines. In the beginning it will be adequate if you have a round, a spoon and a G-nib.

ペン先のいろいろ　Various Nibs

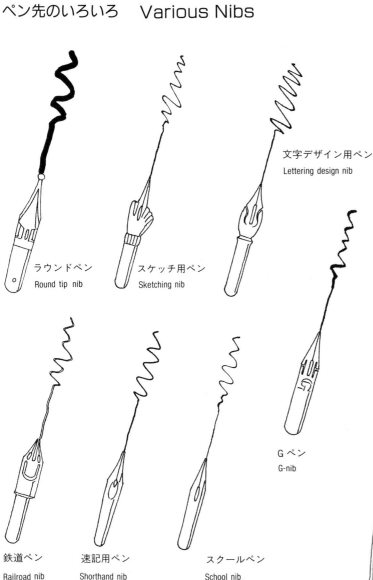

文字デザイン用ペン
Lettering design nib

ラウンドペン
Round tip nib

スケッチ用ペン
Sketching nib

Gペン
G-nib

かぶらペンによる線描
A line drawn using a spoon nib.

鉄道ペン
Railroad nib

速記用ペン
Shorthand nib

スクールペン
School nib

かぶらペン
Spoon nib

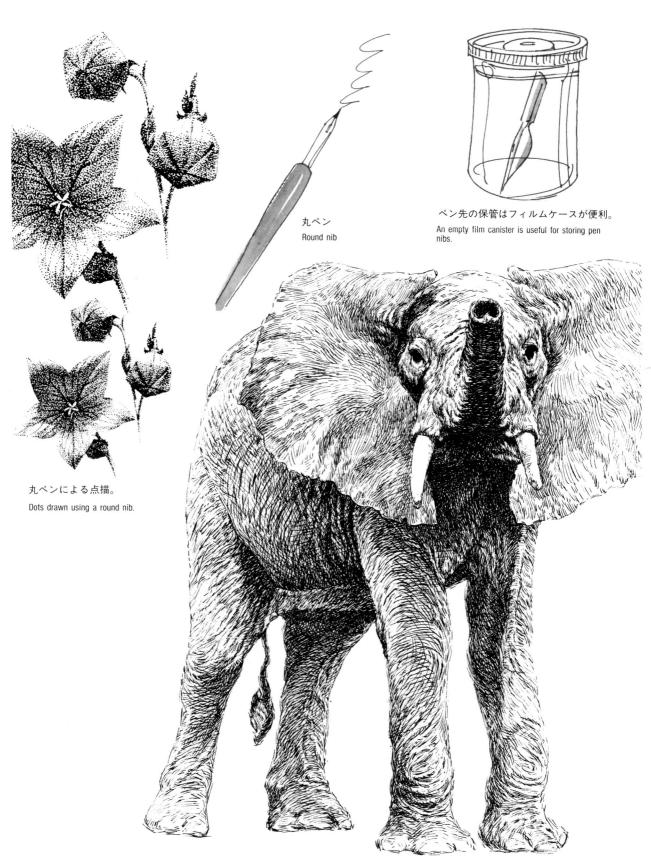

丸ペン
Round nib

ペン先の保管はフィルムケースが便利。
An empty film canister is useful for storing pen nibs.

丸ペンによる点描。
Dots drawn using a round nib.

丸ペンの線タッチ。　Shading created using a round nib.

いろいろなペン
Various Pens

製図ペンは万年筆のようにインクを内蔵し，ペン先が0.1ミリ単位で選べ常に一定の太さの線が引ける。ボールペンは製図ペンほどの精度はないが，一定の太さの線が引けるので便利。また，先がフェルトチップのになっていて，いろいろな太さがあるマーカーもある。

Drafting pens have a self-contained ink supply like a fountain pen. Sizes come in increments of 0.1m/m. so they may be used to create lines of uniform thickness. Ballpoint pens do not come in such accurate sizing, but they are useful as they may also be used to draw a line of consistent thickness. Felt-tip marker pens are also available in a variety of sizes.

ボールペン：水溶性，耐水性の2種類ある。

Ballpoint pens：These come in both water-soluble and water-resistant types.

製図ペン：ペン先は0.1ミリ単位で選べる。

Drafting pens：The tips come in increments of 0.1 m/m.

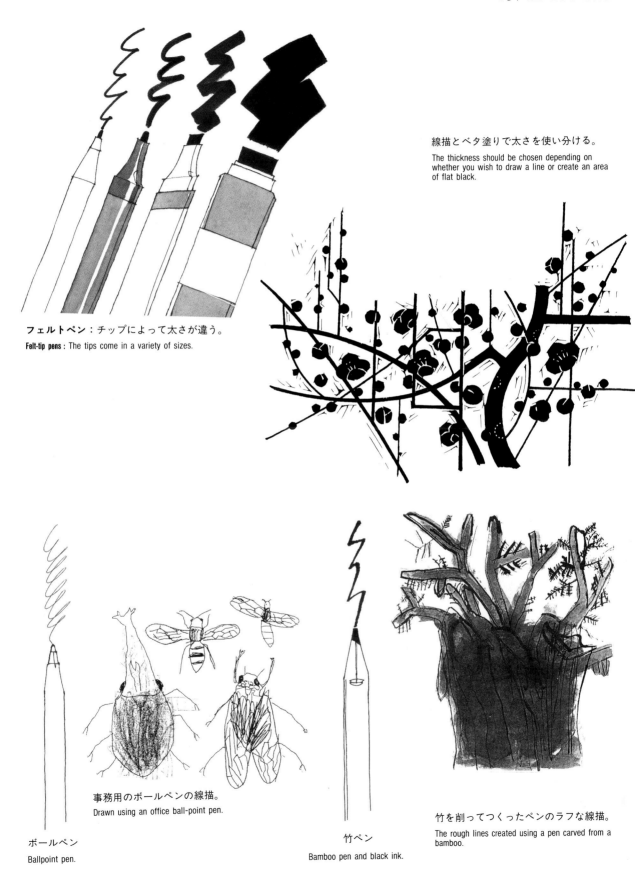

線描とベタ塗りで太さを使い分ける。

The thickness should be chosen depending on whether you wish to draw a line or create an area of flat black.

フェルトペン：チップによって太さが違う。

Felt-tip pens : The tips come in a variety of sizes.

事務用のボールペンの線描。

Drawn using an office ball-point pen.

ボールペン

Ballpoint pen.

竹ペン

Bamboo pen and black ink.

竹を削ってつくったペンのラフな線描。

The rough lines created using a pen carved from a bamboo.

黒インク
Black Ink

耐水性：乾いた後は水に濡れても平気。上に彩色してもにじまない。

Water-resistant Ink : Once it has dried, it will not run even if it is moistened. It will not run if color is applied over it.

水溶性：乾いた後水に濡れるとにじむ。上に彩色するには不向き。

Water-soluble Ink : It will run if water is applied to it after it has dried. It is not suitable for applying colors over.

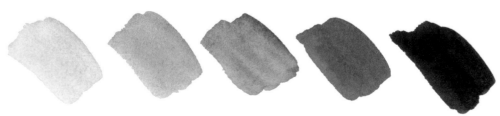

グレートーンはインクを水で薄め濃淡をコントロールしてつくる。水溶性，耐水性とも水で薄めることができる。

A grey tone may be achieved by diluting the ink with water to control the tone. Both water-soluble and water-resistant inks may be watered down.

インクには耐水性と水溶性の2つのタイプがある。線描や点描，黒ベタを生かすなら耐水性の方が修正する場合にホワイトを使えるので有利。グレートーンやにじみの効果を求めるなら水溶性を使う。ときどき瓶を振ることも長持ちのコツ。

Inks come in water-soluble and water-resistant types. If black lines, dots and a flat coat of black are to be used, water-resistant ink is to be recommended as it will allow corrections to be made with white. If a grey tone or wet-in-wet is called for, water-soluble ink should be used. Ink will last longer if the bottle is shaken occasionally.

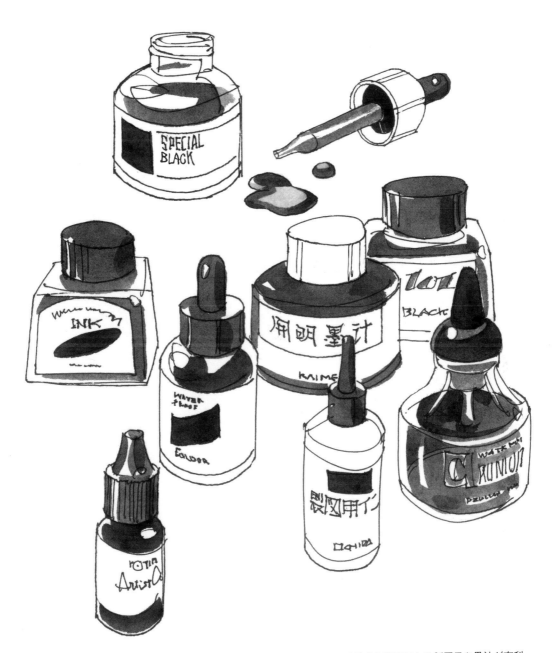

黒インクは乾くと堅牢になる製図用や墨汁が有利。

Drafting ink or Indian Ink are the best types of black ink as they are strong once they have dried.

筆
Brushes

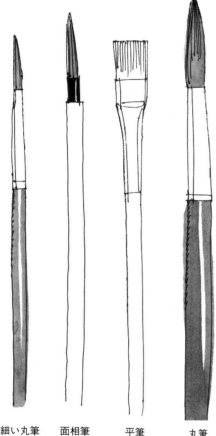

細い丸筆	面相筆	平筆	丸筆
Thin Round Brush	Feature Brush	Flat Brush	Round Brush

菊皿：インクの調合，濃淡を作るときに使う。

Watercolor Palette Dish：This may be used to mix the inks and adjust their density.

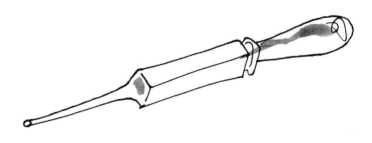

スポイト：インクや水を皿に移すときに使う。

Dropper：This is used to transfer ink or water to the dish.

水溶性のインクを水で薄めてグラデーションをつくる。

Dilute water-soluble ink with water to create a gradation.

ドライブラシでグラデーションをつくる。

Create a gradation using the Dry Brush technique.

ペンと併用してベタ塗りやグレートーン，筆のタッチを求める場合に使う。黒インク専用と彩色専用は分けて使うほうがよい。丸筆はベタ塗り，タッチを変化させるなど用途が広いので中小あると便利。面相筆は細部のベタ塗り用に１本，ホワイトを使う修正用に１本用意したい。

Brushes may be used in conjunction with pens to achieve gradations or areas of flat color. It is a good idea to separate those used for black ink from those used for colors. A round brush is very useful as it may be used to apply a flat coat of color as well as to create variety in the shading and so it is useful to have both a medium and small size. It is a good idea to have two feature brushes, one to apply flat color in the details and the other for white to make corrections.

筆のタッチ　Brush Strokes

インクの含みを少なくしてドライブラシ。
Dry Brush technique, using only a minimum of ink on the brush.

穂先を指でつまんで広げる。
Pinch the tip of the brush with the fingers to spread the hairs.

画面に押し付けて回す。
Press the brush against the paper and revolve.

平筆のベタ塗り
Flat Blush Storokes.

筆圧を変える。
Alter the pressure on the brush.

スピードのある線。
A line applied with vigor.

紙を２つ折りにして筆代わりに使う。

A piece of paper may be folded and used in place of a brush.

ホワイト
White

ポスターカラーかガッシュのホワイトをクリーム状に溶いて，はみ出した部分や形を筆で塗り込み，用紙の白地と同じように見せて修正する。ペンにつけて使える修正用のホワイトインクもある。ペン画の場合は修正だけでなく，新たな形の描き起こしにもホワイトを利用する。

Mix white poster color or gouache to a creamy consistency then use it to cover the areas that have spread outside the outlines and blend them into the white of the paper. White ink is also available that can be used with a pen. In Pen and Ink drawing, white is used not only for correcting but also for lifting out new details.

ガッシュ
Gouache

ポスターカラー
Poster Color

ホワイトインク
White Ink

ホワイトで描き起こす
Adding Details with White

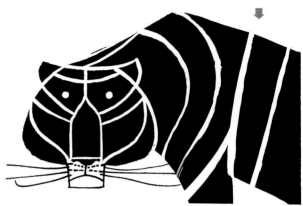

ベタ塗りのシルエットで形を表す。
Express the shape with a flat silhouette.

ホワイトを塗り重ねる。　Build up with the white.

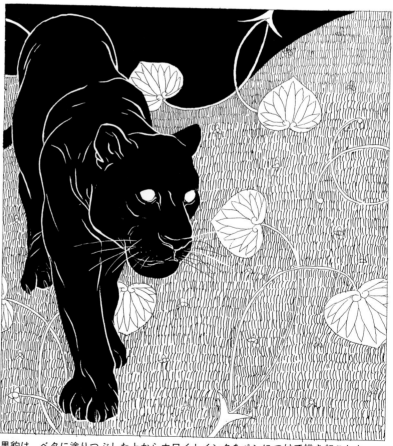

黒豹は，ベタに塗りつぶした上からホワイトインクをペンにつけて描き起こした。
The black panther was expressed using white pen lines over a coat of flat color.

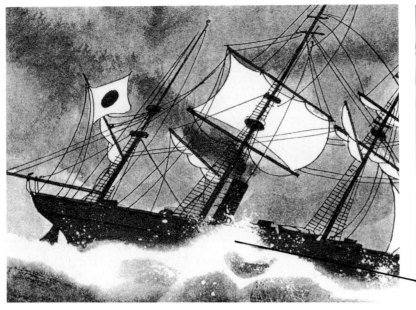

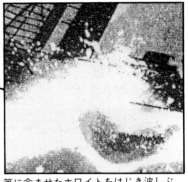

筆に含ませたホワイトをはじき波しぶ
きを表す。

White ink was put on a brush then spattered
against the paper to create the spray of the waves.

広い箇所を修正する
Large Areas Correction

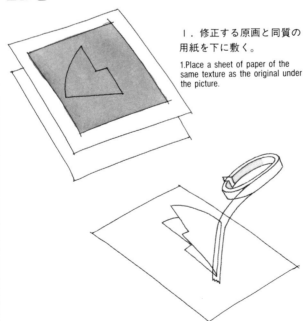

１．修正する原画と同質の
用紙を下に敷く。

1.Place a sheet of paper of the
same texture as the original under
the picture.

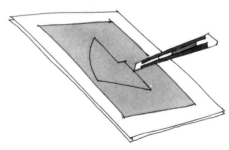

２．修正箇所を下に敷いた用紙と一緒にカットする。

2.Cut out the area to be altered, cutting through both sheets of paper.

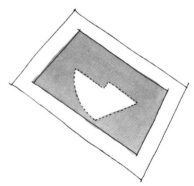

３．カットした同質の用紙を裏返しにした原画にはめ込み
テープで接着する。

3.Turn the picture over then affix the new paper in place of
the area of correction with adhesive tape.

４．原画の修正する箇所は新たな用紙と入れ替わる。

4.The area to be corrected will now have been replaced with
fresh paper.

用紙について
Paper

白黒で表現する場合はペンが引っ掛からず，ベタの塗りムラもできにくいケント紙や画用紙，厚手のトレーシングペーパーを使う。カラーインクをペンのみで線描する場合は，白黒と同じでよいが，筆で彩色して発色効果を高めるには水彩紙がベスト。また，制作中の画面をペンをもった手でこすって汚したり，手の脂っ気をつけてインクがのりにくくならないように，用紙を当てて保護するとよい。

When working in black and white, Kent paper, drawing paper or thick tracing paper is to be recommended as the pen will not catch on the texture and areas of flat color can be applied evenly. When the coloring is to be applied only with a pen, the same papers are ideal, but if a brush is to be used, watercolor paper is better as it will permit the true vividness of the inks to be seen. When working, it is easy to smudge the ink with the hand that is holding the pen or for the oil in the skin to coat the paper making it difficult for the ink to take, so it is a good idea to protect your work with another sheet of paper.

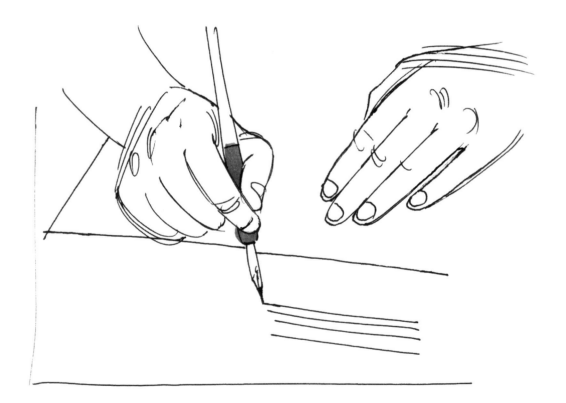

画面を手でこすらないように別の用紙を当てて保護する。

It is easy to smudge the ink with the round that is holding the pen to protect your work with another sheet of paper.

2 章
ペンで描く基本

Chapter 2
The Basics of Pen Drawing

ペンのタッチ
Pen Strokes

　基本的な線や点のほかにも，ペンのいろいろなタッチを工夫してペン画の表現に幅をもたせてみよう。タッチのパターンはたくさんあるが，ひとつの画面にすべてを採り入れるのではなく，必要に応じて組み合わせることがベスト。

In addition to the basic lines and dots, try variations to the basic shading to widen the range of expression. While there are numerous patterns that can be used when shading, these should not all be used in the same picture, but used in combination with each other as the need arises.

いろいろなペンの線 — Various Pen Lines

筆圧を弱める
Weak Pressure

普通の筆圧
Ordinary Pressure

筆圧を強める
Heavy Pressure

点線
Dotted Line

鎖線
Dashed Line

前後に往復
A Line of Built up Strokes

震わせる
Shaky Line

小刻みに引く
Looped Line

筆圧の強弱を繰り返す
A Line with Repeated Heavy and Light Pressure.

いろいろなペンのタッチ
Various Types of Strokes With a Pen

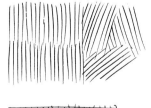

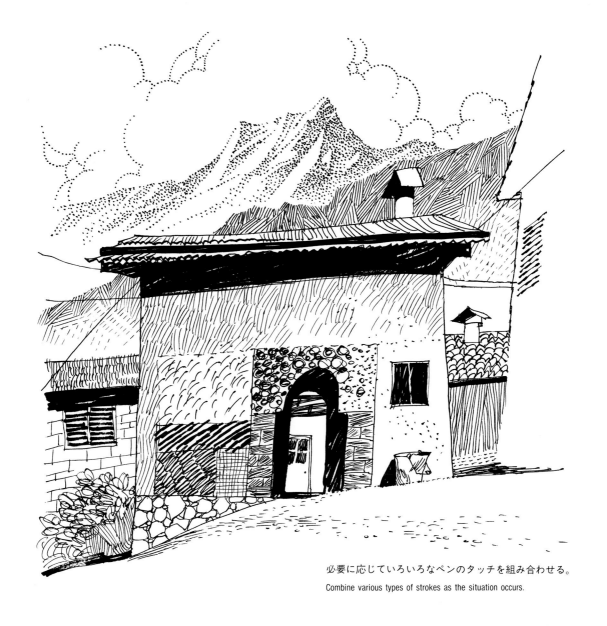

必要に応じていろいろなペンのタッチを組み合わせる。
Combine various types of strokes as the situation occurs.

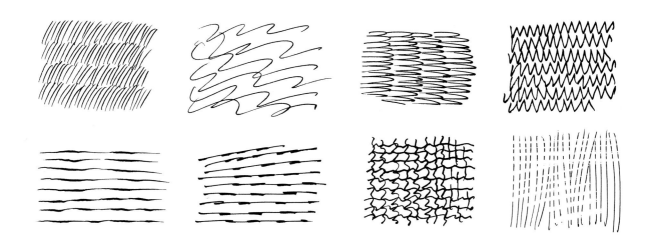

筆圧と筆勢
Pressure and Vigor

弾力性があるつけペンを使い，筆圧や筆勢をコントロールして変化あるペンのタッチをつくろう。一定の筆圧を保ち均質な線，筆勢を変えてスピード感ある線を引くなど，直線や曲線を自在に引けるようにしてペンに慣れよう。

When using a flexible pen nib, pressure and vigor can be altered to create variety in the strokes. Try drawing a smooth line with even pressure, varying the vigor with which a line is drawn to create a sense of speed then experiment with straight and curved lines to accustom yourself to using the pen.

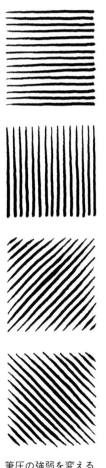

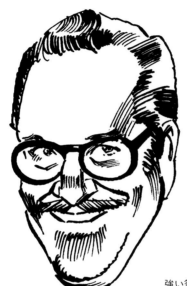

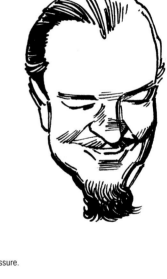

強い筆圧で描く
Drawn using heavy pressure.

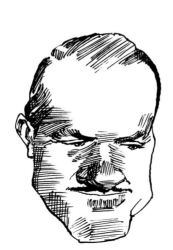

筆圧の強弱を変える
Alter the pressure on the pen.

弱い筆圧で描く
Drawn using light pressure.

直線のタッチで円柱を表す
Straight Lines Used in Shading to Express a Cylinder

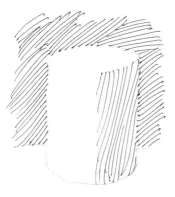

１．バックのタッチで形を表す。

1.Use the shading of the background to express the shape.

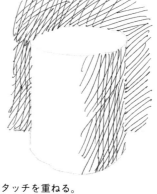

２．さらにタッチを重ねる。

2.Build up the shading further.

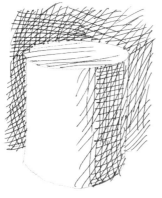

３．タッチを重ね円柱とバックの空間をはっきりさせる。

3.Build up the shading to express a feeling of depth in the background.

４．直線でも明暗の調子を的確にとらえれば丸みは表現できる。

4.If the shading is grasped accurately through the use of straight lines, an expression of roundness may be achieved.

形態に沿ったタッチ
Shading Which Follows the Contours of the Subject

丸みに沿った曲線の太さを変えて立体感を表す。

A feeling of depth may be achieved by altering the thickness of the curved lines that follow the contours of the subject.

線や点の重なりが密になるほど暗く，まばらになれば明るく感じる。ペンで1色の調子を変えるのは，線や点の粗密を利用するのが基本。筆を使う場合はインクを水で薄めて濃淡をコントロールすればよい。

The more densely the lines or dots are drawn, the darker the result while the more widely spaced they are, the lighter it becomes. When using a pen and ink the density of the shading is controlled by the spacing of the lines and dots. When using ink with a brush, it should be diluted with water to achieve the desired shade.

ぼかし網を利用してインクを霧状に散らす。
Use a gradation screen and spray the ink on the paper.

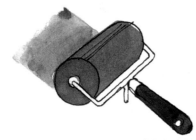

ローラーを転がしてベタ塗りを変化させる。
Run a roller over a flat area of color to create variety.

ペンで調子をつくる
Creating Shading with a Pen

ペンによる調子の変化
Variations in Shading Using a Pen

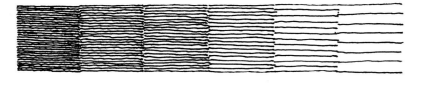

線の密度を変える。
Alter the density of the lines.

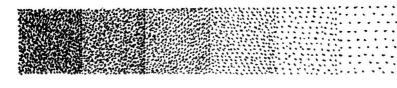

線を交差したクロスハッチング。
The lines crossing each other to create cross-hatching.

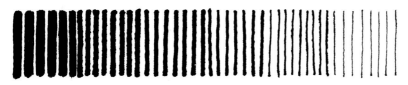

点の密度を変える。
Alter the density of the dots.

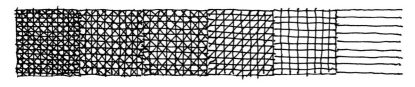

線の太さを変える。
Alter the thickness of the lines.

点の密度を変える
Alter the density of the dots.

線の密度を変える
Alter the density of the lines.

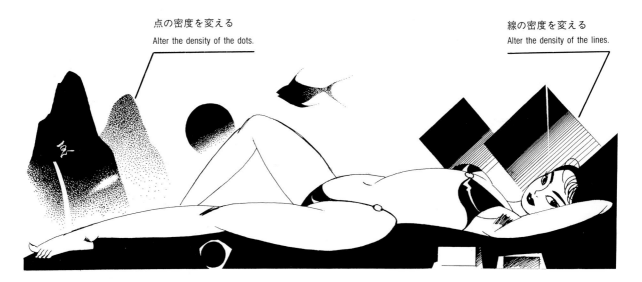

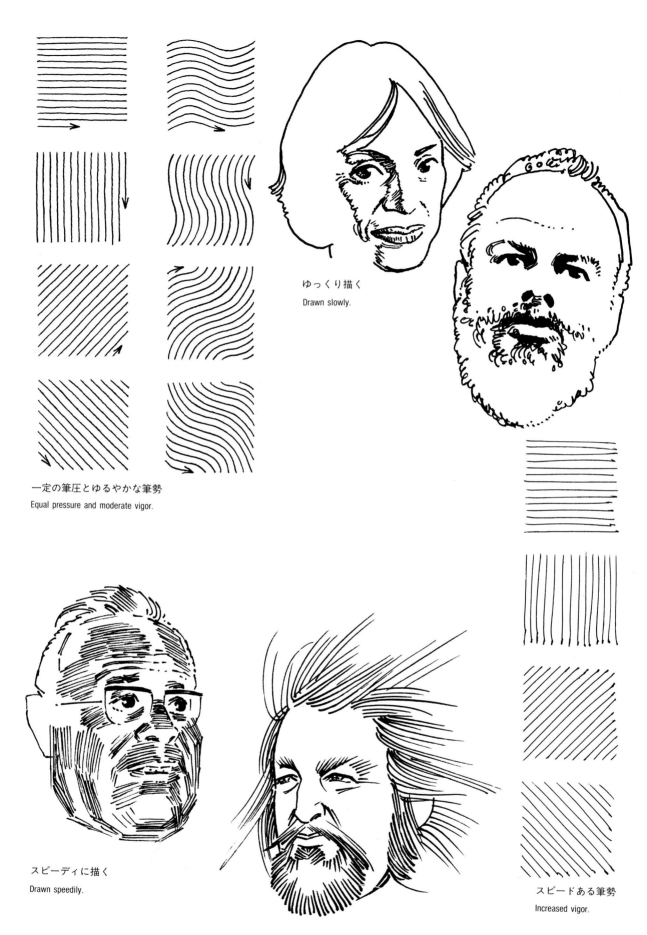

ゆっくり描く
Drawn slowly.

一定の筆圧とゆるやかな筆勢
Equal pressure and moderate vigor.

スピーディに描く
Drawn speedily.

スピードある筆勢
Increased vigor.

23

ペンと筆の調子
Shading with Pen and Brush

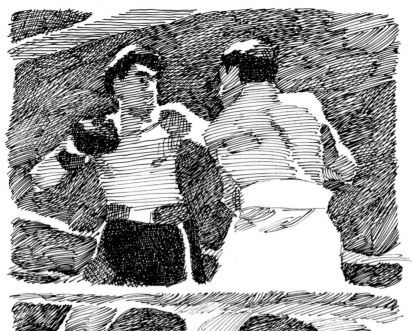

ペンのタッチの密度の差で表現。バックのタッチが人物を際立たせる。

Variations in the shading are expressed through the density of the pen strokes. The shading of the background makes the figures stand out.

ペン：明暗をとらえれば，輪郭線を入れなくても形も立体感も表現できる。形はバックの調子が決め手。個々の形の明暗は 4 つの調子でとらえるとよい。

Pen : If the shading is grasped accurately, a feeling of depth may be achieved even without the outlines being expressed. The shape is expressed through the shading of the background. Each of the objects are expressed through the use of four types of shading.

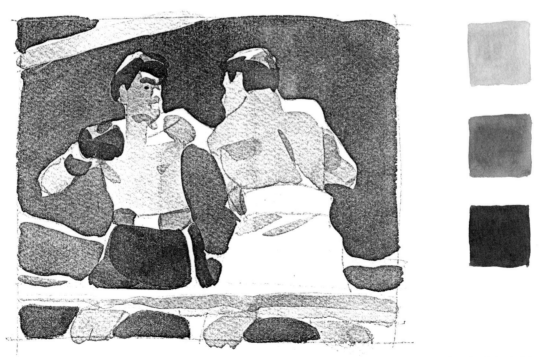

筆：水で薄めた中間の調子にさらに同じ調子を重ねてもよい。用紙の白との対比を効果的に生かそう。

Brush : A mid-tone that has been achieved by diluting the ink may be built up over a previous coat. Effective use should be made of the white of the paper.

クロスハッチング
Crosshatching

シェーカーとグラスを描く（製図用ペン0.5ミリ使用）
Drawing a Drink Shaker and Glass (Using a 0.5 m/m. drafting pen)

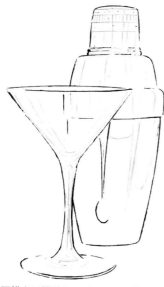

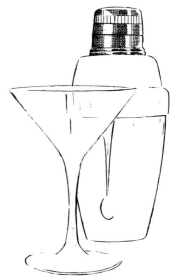

１．鉛筆の下描きは調子やハイライトの境目を正確にとらえておき輪郭線を墨入れする。グラスを通して見えるシェーカーの輪郭の歪みは描写のポイント。

1.Grasp the areas of the shading and highlights in the pencil sketch then add the outlines with ink. Note the distorted outline of the shaker as seen through the glass.

２．円筒形の立体感は縦の粗密を入れてから，斜めのハッチングを交差させる。

2.The cylindrical shape is expressed through dense vertical shading with diagonal hatching laid over it.

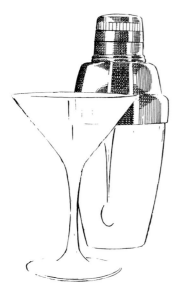

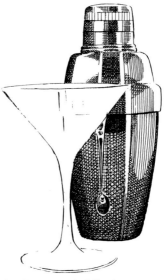

３．明暗のハッチングは写真資料に合わせて行う。写り込みの境目は輪郭線を入れずにハッチングのままにすると自然に見える。

3.Refer to the photograph when adding the shading. The reflections look more natural if they are simply added through shading and do not have the outlines drawn in.

４．下部の丸みはゆるやかな曲線の縦のハッチングをして表す。

4.The roundness of the base is expressed through the gently curved vertical hatching.

線を交差させて調子をつくり立体感を表すペン画の基本的な技法で，金属と透明なガラスを描いてみよう。固い金属やガラスの材質感は規則的なハッチングと形態に沿ってできるハイライト部を表すことがポイント。

The use of cross-hatching for shading to create a feeling of depth is the one of the basic techniques used when drawing with a pen and here it is used to express metal and glass objects. The hard texture of the metal and glass is expressed through the regular lines of the hatching and the highlights which follow the contours of the object.

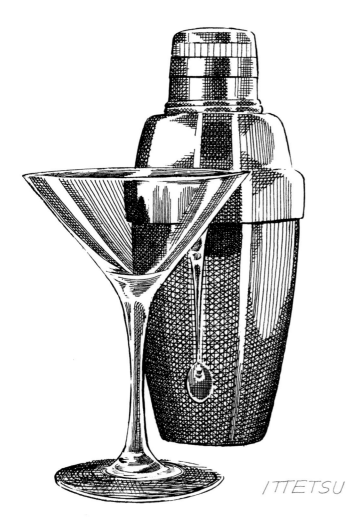

ITTETSU

完成：グラスの透明感は控えめにしたハッチングと，透けて見えるシェーカーを描くことで表現。

The Finished Picture : The transparency of the glass is expressed through restrained hatching and the way in which the shaker can be seen through it.

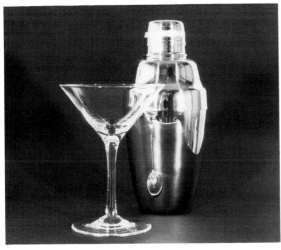

写真資料
The original photograph.

点描
Pointillism

花の細密描写（丸ペン使用）
A Detailed Sketch of a Flower (Using a round pen)

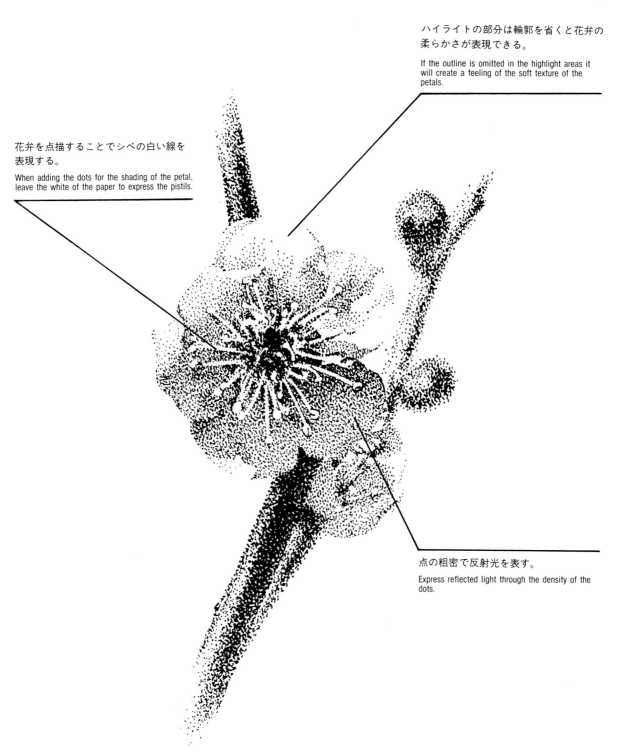

ハイライトの部分は輪郭を省くと花弁の柔らかさが表現できる。

If the outline is omitted in the highlight areas it will create a feeling of the soft texture of the petals.

花弁を点描することでシベの白い線を表現する。

When adding the dots for the shading of the petal, leave the white of the paper to express the pistils.

点の粗密で反射光を表す。

Express reflected light through the density of the dots.

点描は細密描写に適している。点描をする前に鉛筆の下描きで形と陰影の境界線を入れておき、最終的な輪郭線は点で表す。根気のいる技法なので、焦らずじっくり進めなければならない。

Pointillism is ideal for creating detailed sketches. Before starting work on the picture, make a pencil sketch that grasps the overall shape and areas of shadow. Finish the drawing by adding the outline with dots. This technique requires a lot of patience so one must be prepared to take the time to do it properly.

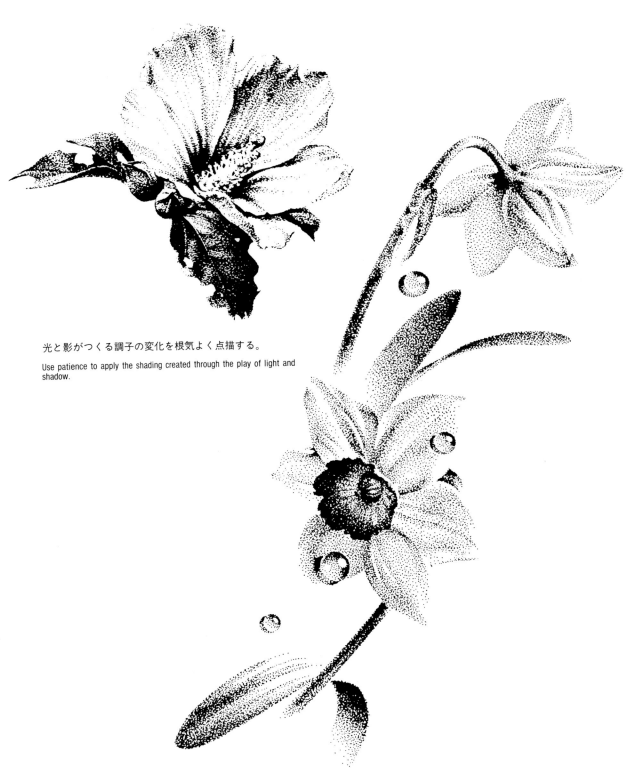

光と影がつくる調子の変化を根気よく点描する。

Use patience to apply the shading created through the play of light and shadow.

点描と線描
Combining Pointillism and Line Drawing

バッタの細密描写（製図用ペン0.1ミリ使用）
A Detailed Drawing of a Grasshopper (Using a 0.1 m/m. drafting pen)

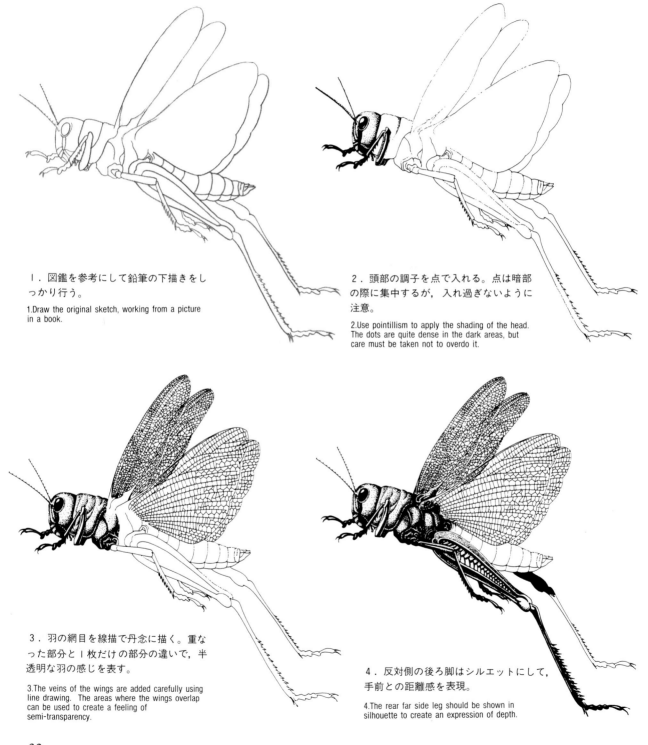

１．図鑑を参考にして鉛筆の下描きをしっかり行う。

1.Draw the original sketch, working from a picture in a book.

２．頭部の調子を点で入れる。点は暗部の際に集中するが，入れ過ぎないように注意。

2.Use pointillism to apply the shading of the head. The dots are quite dense in the dark areas, but care must be taken not to overdo it.

３．羽の網目を線描で丹念に描く。重なった部分と１枚だけの部分の違いで，半透明な羽の感じを表す。

3.The veins of the wings are added carefully using line drawing. The areas where the wings overlap can be used to create a feeling of semi-transparency.

４．反対側の後ろ脚はシルエットにして，手前との距離感を表現。

4.The rear far side leg should be shown in silhouette to create an expression of depth.

極細の製図ペンは均一な点が打てるので，精度を要求される描写に適している。ここでは線描と点描を併用して細密な表現を試みる。鉛筆でしっかり形をとった下描きの上に厚手のトレーシングペーパーを重ねて根気よく描写すること。

A pen with a nib this narrow can create even dots and is ideal for precision work. Here, line drawing has been combined with pointillism to create a very precise expression. Place a sheet of thick tracing paper over the original pencil sketch and work patiently on it.

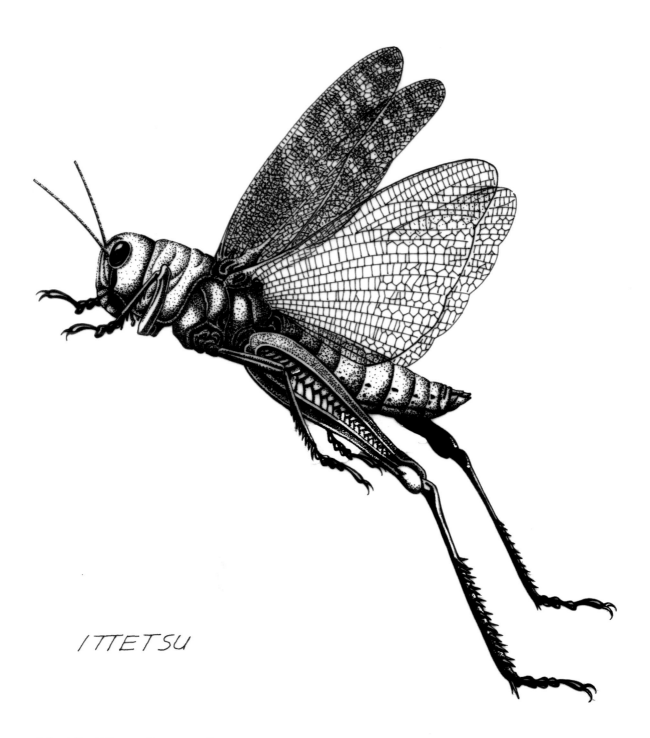

ITTETSU

完成：点描，線描，ベタ塗りの３つの技法で表現した。

Finished Picture : The subject is expressed using three techniques, lines, dots and a flat coat of ink.

線描とグレーの調子
Line Drawings and Grey Tones

１．鉛筆の下描き。全体の調子の配分を
この段階で決める。

1.Start with a pencil sketch. The distribution of the
tones should be decided at this point.

２．輪郭線とベタ塗りをしてから鉛筆の
下描きを消しゴムで消す。

2.After the outlines and the flat tones have been
applied, the pencil should be removed using an
eraser.

インクを水で薄めて２つのグレーの調子をつくる。

Dilute the ink to create the two tones of grey.

線とベタ塗りの黒，2つのグレーの調子，それと
用紙の白地を生かし，4つの調子で表現してみよう。
線描をだめにしないため耐水性のインクを使うこと。

This picture was created using lines and four tones, flat black, two greys and the white of the paper. Waterproof ink should be used in order to avoid the lines being smudged when the flat tones are applied.

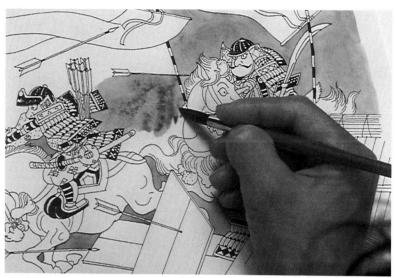

3．明るいグレーの調子を塗る。インクの溜まりでムラにな
らないようスピーディに塗る。

3.Apply the light grey tone. This should be done rapidly to avoid unevenness in the ink.

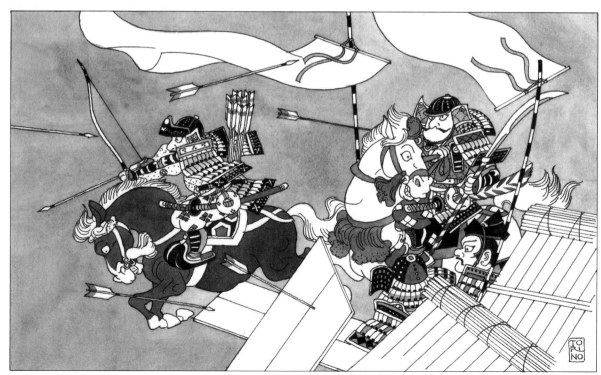

完成：用紙の白地の効果を生かすことも白黒表現のポイント。

Finished Picture : The important thing when creating a monochrome sketch is to take maximum advantage of the white of the paper.

面でとらえる
Understanding the Planes

線のタッチ
Lines

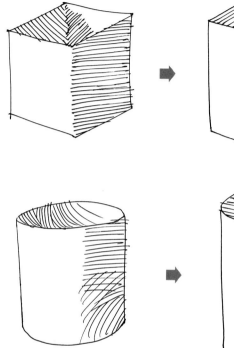

タッチがあいまいだと形態感が弱くなる。

If the lines are added in a half-hearted fashion, the shape will become vague.

面に沿ったタッチを入れて形態感をはっきりさせる。

If the lines are drawn following the surface of the object the shape will become clear.

点描
Pointillism

面が流れる方向を理解して光と陰がつくる調子を入れるとよい。

Once the flow of the planes has been comprehended the shading may be added to express the highlights and shadows.

丸いものは丸みに沿ったタッチを入れると立体感や形態感が強まる。さらに，ものの構造を面でとらえて光と陰の関係を理解し，形態感を表現してみよう。

The shading of the round objects should follow the contours in order to grasp both the depth and shape of the subject. At the same time, one should break a subject down into its basic planes in order to express its form and understand·the relationship between light and shade.

球体に沿った面の方向を理解し光と陰の調子を入れると立体感が強くなる。

If the flow of the planes of the globe are understood before the shading is applied, a greater sense of depth may be achieved.

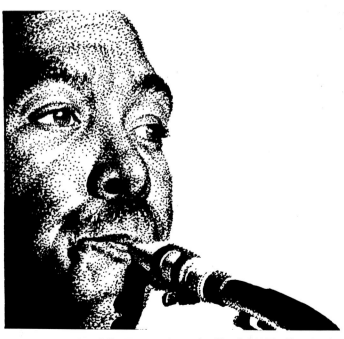

頭部の構造を面でとらえる。光と陰の方向は面に沿っていることを理解して立体感を表そう。

Grasp the basic planes of the face. Express the sense of depth remembering that the light and shade follows the direction of the planes.

顔の構造に沿った線タッチ（製図ペン0.5ミリ使用）

Shading Along the Contours of the Face (Using a 0.5 m/m. drafting pen)

顔の構造に沿った線タッチで乳児を描いてみよう。ペンの線は強いので顔にタッチを入れ過ぎると乳児のかわいらしさが半減する。できるだけ省略してポイントになる箇所を面でとらえよう。

Let's try drawing a baby with the shading following the contours of the face. Pen lines are very strong so care must be taken not to overdo the shading or it will deduct from the appeal of the subject. Simplify the picture as much as possible and only focus on the main points of interest, grasping them as planes

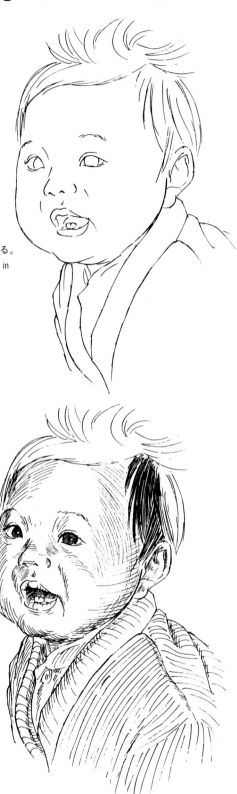

１．鉛筆で下描きする。乳児の場合，目鼻は中央に位置する。

1.Start with a pencil sketch. In the case of a baby, the eyes and nose fall in the center of the face.

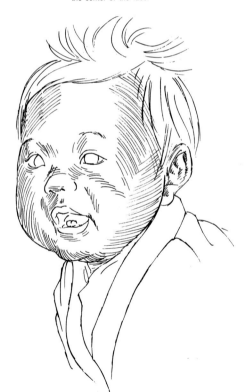

２．面に沿ったタッチを入れ，顔の形態感をつかむ。

2.Add shading following the planes of the face to grasp the feel of the shape.

３．目にハイライトを入れると表情が生き生きする。

3.If a highlight is added to the eyes, the subject seems to come alive.

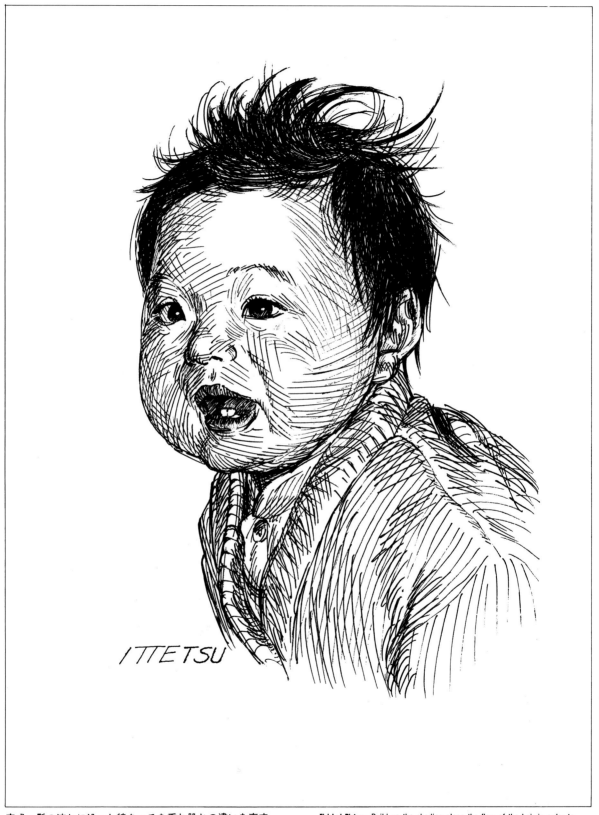

ITTETSU

完成：髪の流れに沿った線タッチを重ね肌との違いを表す。
衣服も布の流れに沿った線タッチを入れる。

Finished Picture : Build up the shading along the flow of the hair in order to make it stand out from the skin. Add shading down the flow of the clothes.

S字形の柔らかな曲線を引けるように練習しよう。
Practice drawing gentle S-shaped curves.

立体感がともなう頭髪は一定の方向に流れるタッチを重ねる。
A sense of depth in a person's hair can be achieved by building up a flowing shading in a single direction.

布の襞を面でとらえ，流れの方向にタッチを重ねて立体感を表す。
Grasp the folds in material as a plane and build up the shading along the direction of its movement to create a feeling of depth.

布や髪をよく観察すると流れやリズムがあること
が分かる。その流れの方向を面でとらえ，線のタッ
チの粗密を採り入れて自然な立体感をもたせよう。

If you study material or hair, you will notice that
there is a flow and rhythm to it. If you grasp the
direction of the flow as a plane and control the
density of the shading along it, you will
automatically achieve a sense of depth.

人物の動きによってできるシワの流れを
線のタッチで表す。

The flow of creases in clothes caused by the
wearer's movement is expressed through line
shading.

脚の丸みに沿ったタッチを入れる。

Add shading along the roundness of the legs.

曲面に沿った線は立体を表す。

The round objects should follow the con tours in order to grasp both the
depth and shape of the subject .

定規を使う
Using a Ruler

金属質を表す（0.1ミリ製図ペン，筆ペン使用）

Expressing the Texture of Metal (Using a 0.1 m/m. drafting pen and brush pen)

　いろいろな定規を使って引いた直線や曲線は，フリーハンドの線と比べると冷たく無機的な感じがする。工業製品や建築パースのレンダリングなどを描く場合に向いている。

Lines can be drawn using a variety of straight or curved rulers but the result always appears colder and more mechanical than that achieved through freehand. For this reason they are ideal for technical illustration or architectural sketches.

　１．定規類を使って鉛筆で下描きをする。マフラーの曲線は厚紙を切って作った定規を使う。

1.Draw the basic sketch using a pencil and ruler. The curve of the muffler was drawn using a stencil cut from cardboard.

　２．全体のアウトラインを製図ペンで描き起こす。

2.Go over the outline using a drafting pen.

　３．写り込みを描くことでマフラーのメタリックな材質感を表す。明暗の対比を強調することがポイント。

3.The metallic feeling of the exhaust pipe is accentuated by the strong contrast and the addition of reflections in its surface.

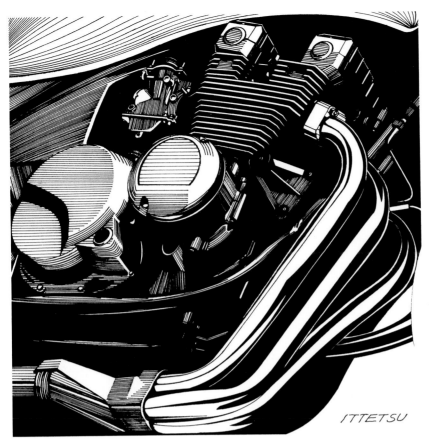

ITTETSU

完成：製図ペンと定規を使った直線が固い金属質とスピード感を表す。ベタの部分は筆ペンで塗りつぶしている。

Finished Picture : The use of a drafting pen and ruler produced a sharp, metallic texture and created a feeling of speed. The area of flat color was added using a brush pen.

定規で引いた線（左）は，フーハンド（右）に比べ冷たく無機的。

The line which was drawn with a ruler (left) is more mechanical than that which was drawn freehand (right).

厚紙を切って作った定規。

A ruler that was cut from a sheet of cardboard.

筆ペンを使う
Using a Brush Pen

筆ペンは万年筆のようにインクを内蔵しているので，一気に太い線やベタ塗りができるので便利だ。作例のように暗部を先に筆ペンでつぶしておいてから，つけペンで徐々に中間部の調子を描き起こすと効果的な表現ができる。

A brush pen has an internal supply of ink which makes it very useful for drawing broad lines or creating a flat area of color. As can be seen from the example, it is very effective if it is used to fill in the dark areas first before gradually adding the mid-tone with a dip pen.

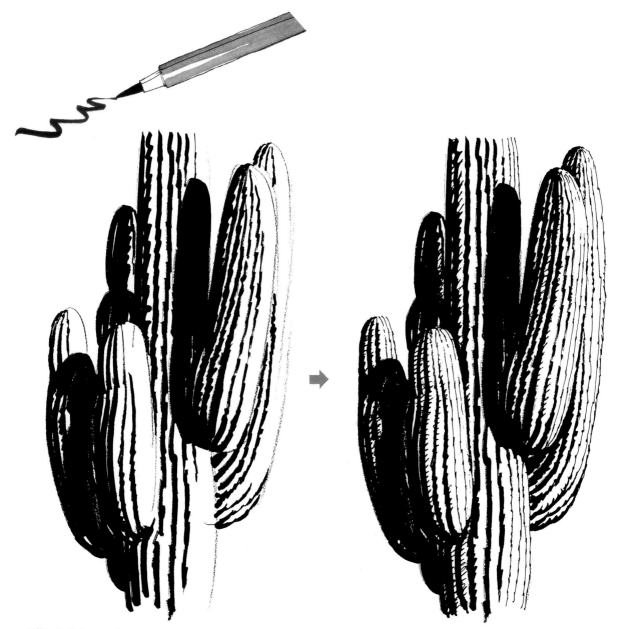

鉛筆の下描きの上に筆ペンでサボテンの陰影を一気に描く。

The shadow areas of the cactus were added to the pencil sketch using a brush pen.

筆ペンでドライブラシを交えたベタ塗りしてから，ペンの線タッチを入れる。

After the flat area has been applied using a brush pen and dry brush, the drawing can be added using a dip pen.

筆ペンで暗部のベタ塗りをしてから丸ペンで中間の調子を入れる。

A brush pen was used to apply the dark areas then a round pen was used to add the mid-tone shading.

輪郭線を筆ペンで描き薄めたインクで中間調を塗る。

A brush pen was used to apply the outline then the mid-tones were added using diluted ink.

フェルトペンを使う
Using a Felt-tip Pen

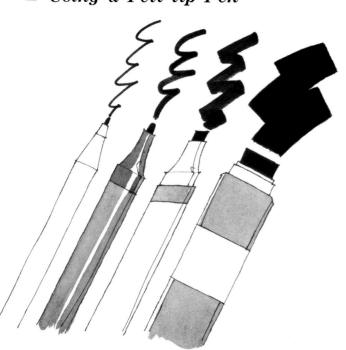

1. 鉛筆で下描きをする。

1.Draw the basic sketch with a pencil.

2. 下描きの上にトレーシングペーパーを重ね，油性マーカーのグレーを2種類使って形と明暗の調子をつける。

2.Place a sheet of tracing paper over the sketch then use two oil-based felt-tip greys to fill in the shape and tones.

3. さらに黒の強い調子を重ねメリハリをつけて完成。

3.Add some deeper black shading to produce an accent in the picture and it is complete.

46

芯がフェルトでできているマーカーは太さも，グ
レーの調子もいろいろある。白黒で表現する場合，
このグレーを塗り重ねるとさらに暗い調子ができる。

Felt-tip pens come in a variety of sizes and tones of
grey. When making a black and white drawing,
these greys can be built up to create an even darker
tone.

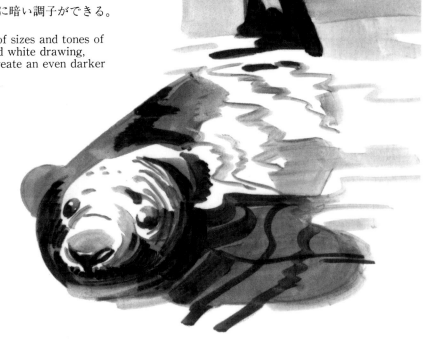

3 種類の調子を使って描く。
Drawn Using Three Types of Shading.

使い込んだ水性フェルトペンの線は，ドライブラシ風なイン
クのかすれがおもしろい。

An old, water-based felt-tip pen may be used to create an interesting
dry-brush effect.

画材の配置
The Layout of Materials

制作しやすいように画材や用具を配置しよう。右手で扱うものは右側においておくとスムーズに制作を進めることができる。頻繁に使う黒インクはビンの底に両面テープを張り扱いやすい位置に固定しておくと倒す心配がない。下描きをトレースするライトテーブルがあれば便利。

The materials should be laid out in such a way as to make it easy to work. If the items that you use in your right hand are placed on the right side, it will allow you to work smoothly. If the bottle of black ink which is most frequently used is fastened to the desk in a convenient position with double-sided tape there will be no danger of knocking it over while you work. A light box is useful when tracing a sketch.

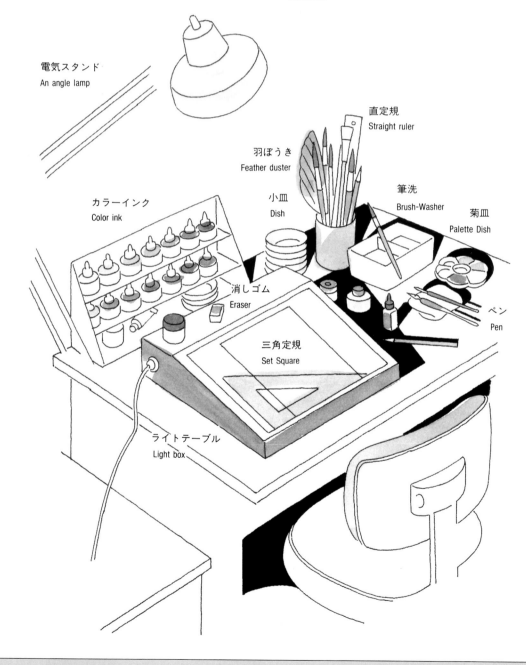

電気スタンド
An angle lamp

直定規
Straight ruler

羽ぼうき
Feather duster

筆洗
Brush-Washer

菊皿
Palette Dish

カラーインク
Color ink

小皿
Dish

消しゴム
Eraser

ペン
Pen

三角定規
Set Square

ライトテーブル
Light box

3 章
カラーインクの基本

Chapter 3
The Basics of Color Ink

カラーインクの特徴

The Characteristics of Color Ink

　カラーインクの特徴は抜群の発色力と透明性にある。水で薄めて使うことができ、乾いてしまうと耐水性になるタイプ、乾いても塗り重ねると混ざり合う水溶性タイプの2種類がある。初めて扱う場合、塗り重ねの効果を生かせる耐水性の方が無難だろう。

Color inks have excellent color brilliance and transparency. They may all be diluted with water but some of them become waterproof when they dry while others dissolve and blend with inks that are applied over them. In the beginning it is probably easiest to use water-resistant inks as these may be used to create a glazing effect.

発色の効果
The Color Brilliance

　発色がよく高彩度なカラーインクの特徴を生かし，補色同士を配色する。隣り合う色が反発しあってハレーションを起こす。作例は原液のままと水で薄めて使用している。

In order to take advantage of the brilliance and high color saturation of the inks, complementary colors should be used together. The adjacent colors attempt to repel each other, creating halation. In the example shown here, I have used both diluted and undiluted inks.

原液の色
Undiluted color.

カラーインクは水で薄めても発色効果を保つ。
Even when color ink is diluted, it does not lose its brilliancy.

水で薄めた色。
Diluted color.

水で薄めて彩色する

　カラーインクの色が濃すぎる場合は，水で薄めて調整する。明るい肌色，陰の暗い肌色も自由につくることができる。

Coloring with Diluted Ink

If the color of the ink is too dark, it may be diluted with water. In this way it is easy to achieve both light skin tones and dark tones for the shadow areas.

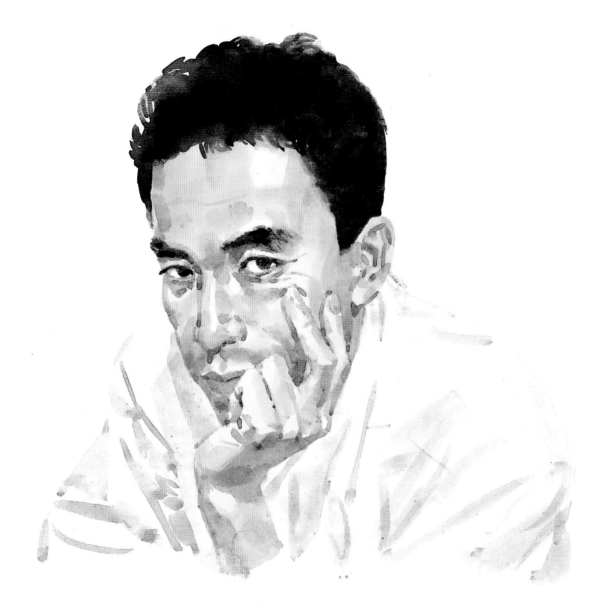

肌色に使用した原液の色。

The original color of the ink used for the skin tones.

ペンによるハッチング

ペンで異なった色線をクロスハッチングして視覚的な混色効果をあげる。作例は5色をクロスハッチングした。

Crosshatching with a Pen

A pen can be used to produce crosshatching using different colors and this creates an illusion of mixed color. In the example, five colors were used in the crosshatching.

透明性を生かす
Utilizing the Transparency of the Ink

　カラーインクは液体の透明水彩絵具ともいわれ，色を塗り重ねるとセロファンを透かして見るような混色効果がある。この効果を生かしカラーインクならではの深みのある透明な色調をつくってみよう。

Color inks are sometimes referred to as liquid transparent watercolors and when one color is laid down over another, it is like looking at the first color through colored cellophane. When using colored inks this property should be utilized to create a deep, transparent tone.

下の色と塗り重ねた色が混ざり合って見える。
The base color and the upper color appear to mix.

塗り重ねで微妙な色調をつくる。
Colors may be built up to create delicate tonal variations.

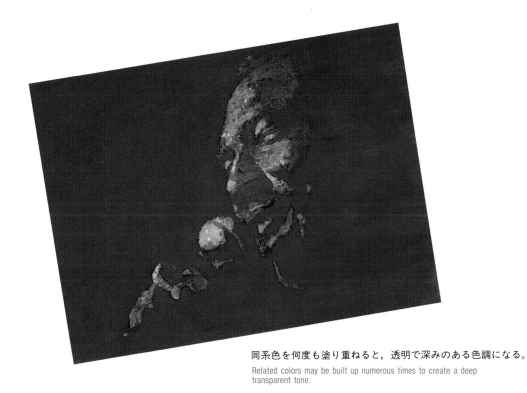

同系色を何度も塗り重ねると，透明で深みのある色調になる。

Related colors may be built up numerous times to create a deep transparent tone.

色を塗り重ねても先に引いたペンの線が生きる。

Even when colors are built up over a line, it remains visible.

筆で彩色をする
Coloring with a Brush

肌色のつくりかた
How to make the skin tone.

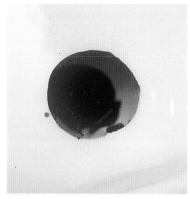

赤を基調色にする。
Red is the base color.

黄色と緑をわずか混ぜる。
Addsmall quantities of yellow and green.

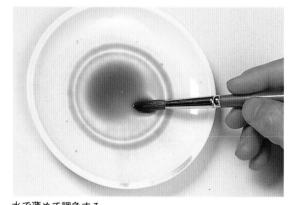

水で薄めて調色する。
Dilute with water to achieve the required color.

１．鉛筆の下描き。
1.The original sketch is drawn with a pencil.

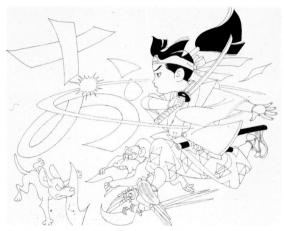

２．カラーインクで輪郭線を入れてから墨のベタを塗る。両者とも耐水性のインクを使用。

2.After drawing the outline using colored ink, the areas of
flat black are added. All the ink used at this point should be waterproof.

３．混色してつくった肌色を塗る。
3.Paint a skin tone that was created through mixing.

カラーインクで輪郭線を入れ，筆で彩色してみよう。丸ペンで入れる輪郭線以外は混色し水で薄めるが，カラーインクの彩度も透明度も損なわれはることはない。耐水性のインクを使用しても，必ず前に塗った色を乾かしてから次の彩色を行うこと。

Try drawing the outline with color ink then using a brush to add the color. Apart from the lines that are drawn using a round nib, the colors should be mixed and diluted to achieve the required color but this should not result in a loss of color saturation or transparency. Even when using water-resistant ink, it is important to ensure that the base color has dried before going over it with another color.

４．頬は色鉛筆の赤を塗り重ねる。
4.Build up the red of the cheeks using a red pencil.

５．赤を綿棒でぼかす。
5.Blend the red using a tortillon.

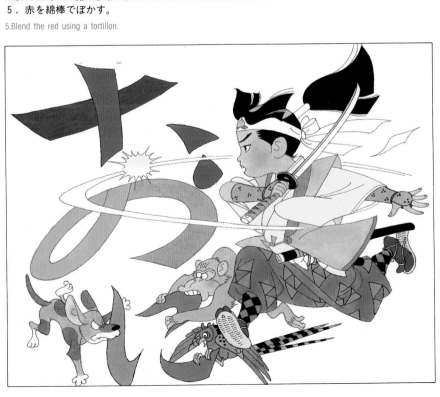

完成
Completed Picture

にじませる
Wet-in-wet

予め水を含ませた筆で彩色する箇所を湿らしておいて，ペンや筆でインクをつけると色がにじみ，単なる彩色とは異なる絵肌ができる。また，生乾きの彩色面に水を垂らすと前者とは一味異なるにじみをつくることができる。

If the area to be colored is moistened with a wet brush first, when the ink is applied with a brush or pen, the color will run and produce a different effect to simple coloring. Again, if water is dropped on an area of coloring before it has quite dried, it will create yet another effect.

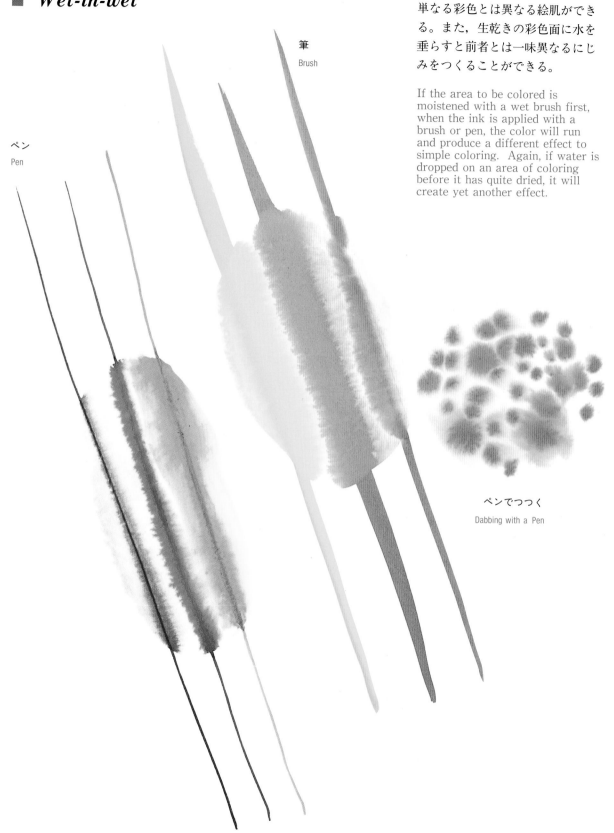

筆
Brush

ペン
Pen

ペンでつつく
Dabbing with a Pen

湿らした箇所に彩色

Applying color to a moistened area

生乾きの彩色面に水を垂らす。

Dropping water on an area of color that has not yet dried.

生乾きの彩色面にさらにペンで彩色。

Coloring with a pen on an area of color that has not yet dried.

生乾きの彩色面にさらに別の色を垂らす。

Dropping a second color on an area of color that has not yet dried.

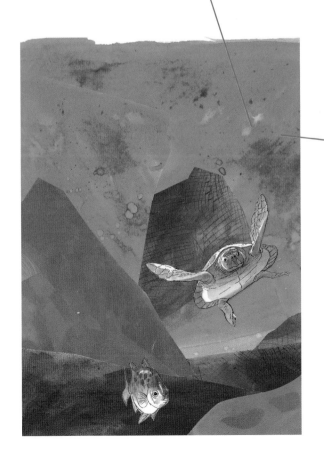

色をぼかす
Color Gradations

ぼかしは，水を含ませた筆で生乾きの彩色面を吸い取るようにする方法と水で湿してからぼかす方法がある。

There are two ways of creating a gradation, the edges of a color may be gone over with a wet brush before it has completely dried, or the paper can be dampened before the ink is applied.

ぼかす部分を水を含ませた筆で湿らせる。

Use a brush to moisten the area which is to have the gradation.

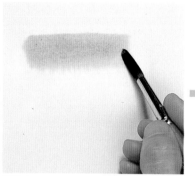

彩色する。

Add the color.

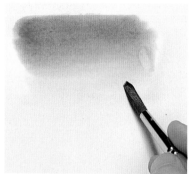

徐々に色が薄くなる。

The color becomes gradually lighter.

バックをぼかした例。

Gradation of background.

インクが乾かないうちに水を含ませた筆
でこすってぼかす。

A wet brush is used to blur the ink before it has
dried.

混色
Mixing Colors

イエロー
Yellow Ink

インディゴ
Indigo Ink

カーマイン
Carmine ink

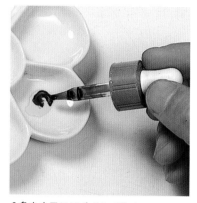

2色を小皿にスポイトで移す。
Add indigo to the yellow.

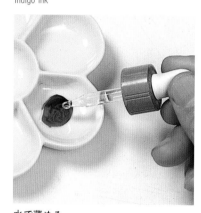

水で薄める。
Add water to dilute the ink.

高彩度のグリーンができる。
A green with a high color saturation is achieved.

2色を混ぜても彩度は落ちない
Even if two colors are mixed, the color saturation is not effected

	イエロー Yellow	カーマイン Carmine	インディゴ Indigo
イエロー Yellow			
カーマイン Carmine			
インディゴ Indigo			

小皿で2色を混ぜて新しい色をつくってみよう。
2色程度の混色では彩度が低くならないのがカラー
インクのよさだ。インクの量の加減で色は微妙に異
なるが，これは何度か繰り返して慣れて欲しい。

Try mixing two colors in a dish to create a new color. One of the advantages of using colored ink is that if only two colors are mixed, it will not effect the color saturation. Small differences in the amount of ink used will create minute differences in the final color so plenty of practice is recommended in order to learn to control this.

ペンで彩色する
Coloring with a Pen

ペンの扱い
Using a Pen

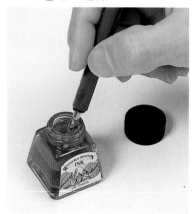

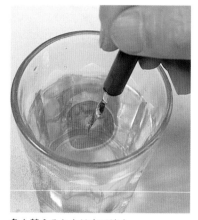

色を替えるときは水で洗う。

When changing colors, wash the nib in water.

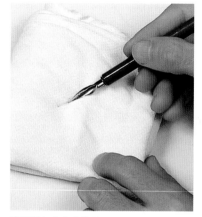

布で汚れをふき取る。

Wipe the tip of the nib with a cloth.

線の混色
Mixing Colors Through Lines

織物のように縦糸横糸の関係で行う。

Use different colors for the vertical and horizontal lines, like the warp and weft of cloth.

点の混色
Mixing Colors Through Pointillism

点の割合で色が変わる。

The color is decided by the ratio of colored dots.

インクを直接ペンに付けて引く線は，力強さも繊細さも表現できる。異なる色線のハッチングや点描で視覚上の混色効果をつくり，カラーインクでしか表現できないペン画にチャレンジしよう。ペンは暖色と寒色で使い分け，ときどきペン先に付着した汚れをふき取ってインクビンの色を濁さないようにしよう。

Drawing directly with a pen allows the creation of both strong and delicate lines. Hatching or pointillism with different colored inks produces an illusion of mixed color and permits expressions that cannot be achieved through any other medium. When working with colored inks, you should keep one pen for warm colors and another for cold colors, occasionally wiping the tip of the nib to prevent the ink in the pots becoming contaminated.

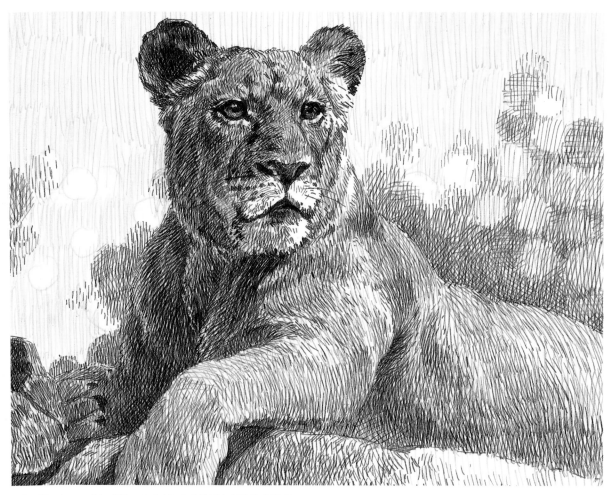

面に沿ったハッチングは，ライオンの立体感と毛並みを表す。

The lines following contours of the lion create a feeling of depth while expressing the texture of its coat.

線と彩色
Line and Coloring

ペンのタッチとカラーインク

　ペンと黒インクで表す固く鋭い線，柔らかな曲線，細かなタッチなどを彩色面に入れることでイラストレーションの個性は明確になる。また，黒インクの強さがメリハリとなって，筆で彩色した画面を引き締める働きをする。黒インクは必ず耐水性のものを使用すること。

Pen Strokes and Colored Ink

The hard, sharp lines, the soft lines and the fine shading that are associated with pen and black ink drawing may be adopted in colored areas to create a distinctive illustration. The strong lines of the pen provide an accent which will draw a brush picture together. It is important that the black ink used should be water-resistant.

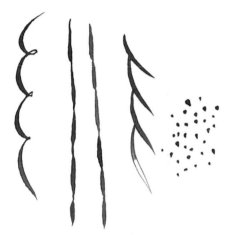

Ｇペン：筆圧の強弱で線は変化する。

G Pen : Differences in pressure provide variation in the lines.

輪郭線の太細，点や細かなタッチで表情をつくる。

The different thicknesses in the outline, the dots and fine shading that create the characters expressions.

輪郭線を入れて細かなものの形を表す。

Used to add the outlines and delicate shapes.

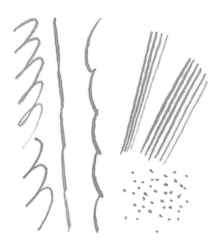

かぶらペン：一般的に使われ，Ｇペンと同様に筆圧の強弱で線は変化する。

Spoon Pen : This commonly used pen is similar to the G pen in that differences in pressure produce variation in the lines.

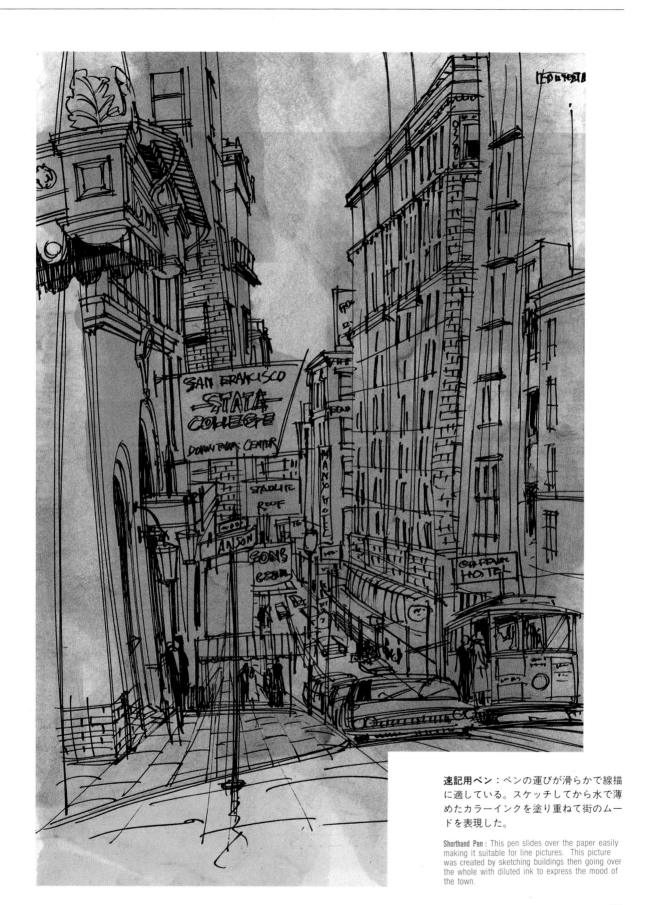

1色のハッチング効果
The Effect of Single-Color Hatching

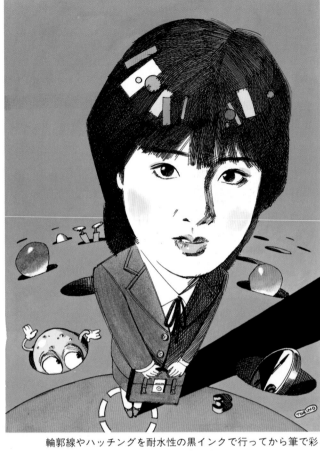

輪郭線やハッチングを耐水性の黒インクで行ってから筆で彩色し，線と色のコントラストを生かす。

The outline and hatching was done using water-resistant black ink, then the coloring was added using a brush to bring out the contrast of the lines and color.

筆で彩色してから黒インクで面に沿ったハッチングを行い立体感を表す。

After the color was applied with a brush, black ink was used to produce hatching around the outline and create a feeling of depth.

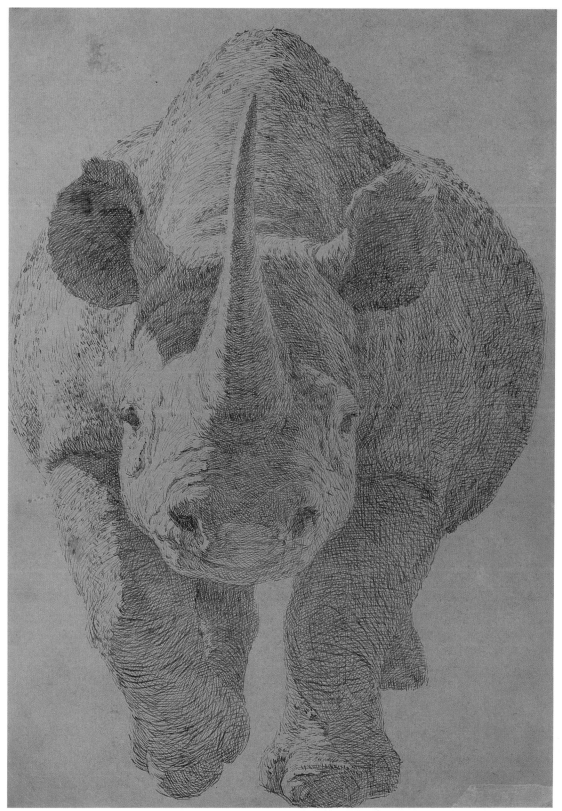

カラーペーパーにインク1色を使用。光と陰がつくる凹凸面に沿ったハッチングとクロスハッチングで形態感を表し，輪郭も線の粗密で表す。

One color of ink was used on colored paper. Hatching and crosshatching was applied to the shadow areas caused by the contours of the subject to express the shape. The outline was expressed through the density of the lines.

線の太さが一定の製図ペン
A Drafting Pen Produces Lines of Equal Thickness

製図ペンで引く線は固く冷たいイメージがあるが, フリーハンドで引くと意外に暖かみがある。太さが一定した輪郭線を入れる際に便利。

The lines produced by a drafting pen are hard and cold, but if it is used freehand, it can produce an unexpectedly warm effect. It is very useful when an even thickness is required for the outline.

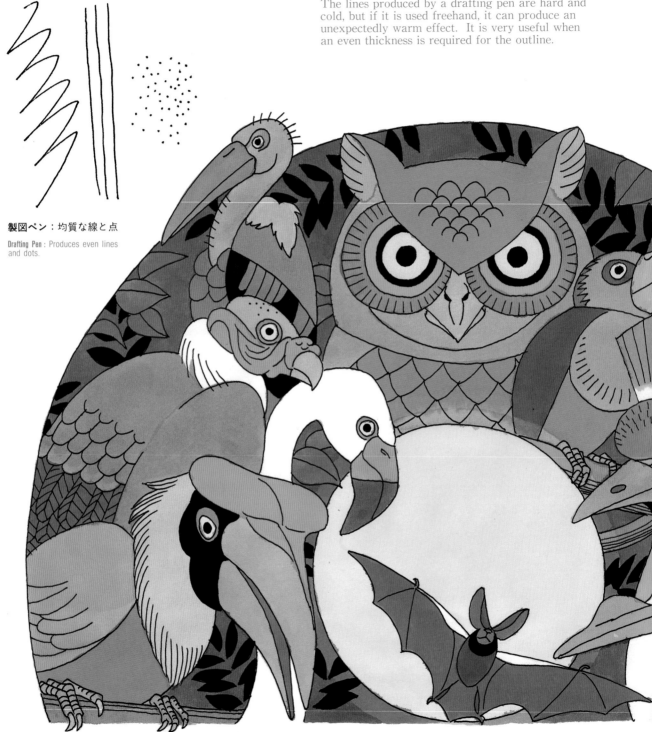

製図ペン: 均質な線と点

Drafting Pen: Produces even lines and dots.

鉛筆の下描きに沿って輪郭線を入れてから彩色。彩色が多少ずれても輪郭線が個々の形をはっきりさせる。

The outline was added over a pencil sketch then colored. Even if the color should spread a little, a clear outline allows the shape of the subject to be readily understood.

線と墨ベタをポイントにして彩色は補助的にする。

The main emphasis is on the lines and the areas of flat black. The coloring is only secondary.

輪郭線，墨ベタを入れてから彩色。輪郭線からずらしたフラットな彩色でコミカルな動きを表す。

The color was added after drawing the outlines and areas of flat black. The color that has been allowed to spread beyond the outline expresses the comical movement of the characters.

カラーインクの彩色効果

The Effect of Coloring

筆の軸をテコにして乾いた彩色面に色を散らす。

Using the handle of a brush as a fulcrum to spatter color over an area that has dried.

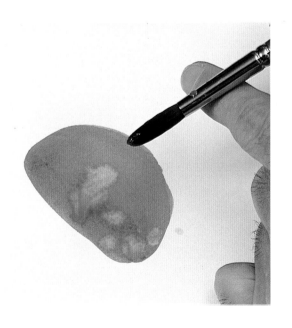

生乾きの彩色面に水を散らす。

Spattering water on a colored surface before it has dried.

カラーインクは筆やペンで彩色するのがオーソドックスな方法だが，ここでは彩色面を変化させるテクニックを紹介しよう。

Coloring with a pen or brush is an ordinary technique, but here I would like to introduce some more unusual methods.

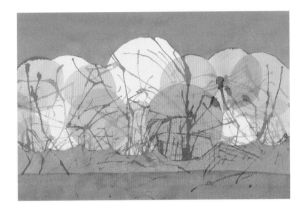

たっぷりつけたインクの溜まりに息を強く吹きかける。

Blow hard on a blot of ink that has been applied to the paper.

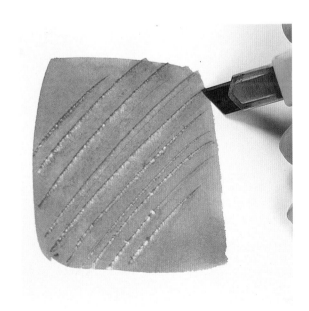

生乾きの彩色面をカッターナイフで引っ掻く。

Scratching the surface of the color before it has completely dried.

用紙と発色効果
Paper and its Effect on Brilliance

カラーインクの発色効果的は用紙によって左右される。筆で彩色する場合は水彩紙が有利。ケント紙は色ムラができるので避けるが，ペンを主に使う場合はペン先を滑らかに運べるのでお勧めしたい。粗い紙目の水彩紙は製図ペンがひっかかるので，極細を使った方がよい。

The type of paper used controls the brilliance of the coloring. When using a brush to apply the ink, watercolor paper is ideal. If Kent paper is used, it will create an unevenness in the color but it is ideal when only a pen is used as it will allow the nib to glide over the surface smoothly. If watercolor paper with a rough texture is used, it might hinder the movement of the nib of a drafting pen so a smooth texture is to be recommended.

用紙による発色のちがい Difference of effect on brilliance with paper.

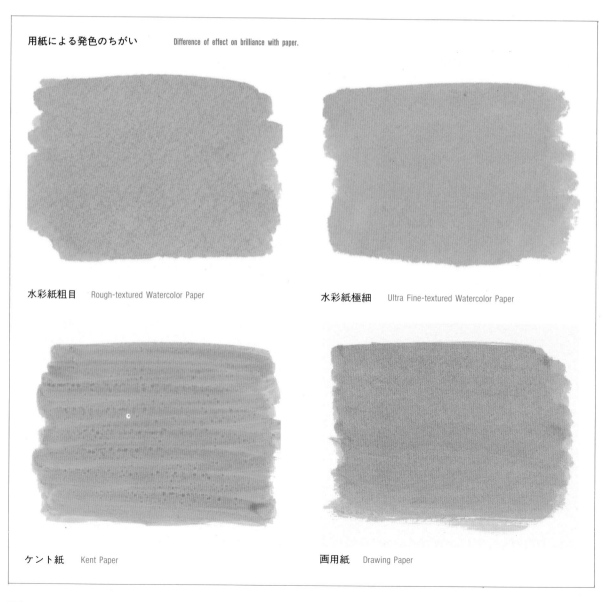

水彩紙粗目 Rough-textured Watercolor Paper

水彩紙極細 Ultra Fine-textured Watercolor Paper

ケント紙 Kent Paper

画用紙 Drawing Paper

中目の水彩紙：カラーインクを水で薄めて彩色しても発色効果は抜群。弾力性のあるかぶらペンを使えば，スムーズに輪郭線が引ける。

Medium-textured Watercolor Paper : The brilliance of the ink is excellent, even when it has been diluted with water. If a flexible nib such as a Kabura is used, the outline may be drawn smoothly.

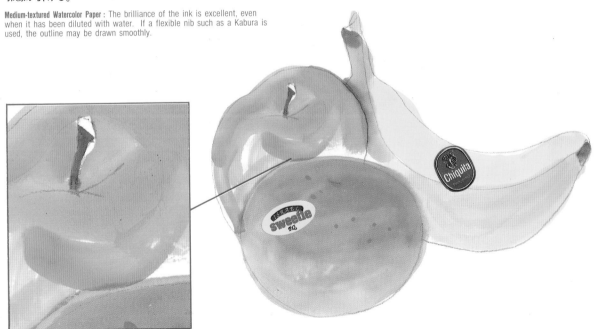

画仙紙：発色効果はよいが，吸収性があるので筆のタッチが残る。シールは実物を張り付けた。

Chinese Drawing Paper : While the brilliance is excellent, it tends to soak up the ink so the brush strokes remain. The labels were removed from the fruit and fixed to the picture.

筆のタッチを生かすメディウム
Creating Brush Strokes

カラーインクにアクリル絵具用のグロスメディウムを混ぜると色はわずかに薄くなるが，筆のタッチが残る位の粘り気をもつようになる。この性質を利用して変化ある絵肌をつくってみよう。

If Acrylic gloss medium is added to color inks, the colors will become slightly lighter, but it will make the ink thick enough for the strokes to remain visible. This characteristic can be used to produce variety in the surface of the picture.

グロスメディウム

Gloss Polymer Medium

カラーインクにグロスメディウムを混ぜる。

Mix with gloss medium.

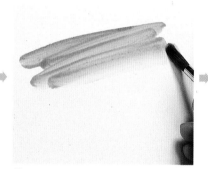

筆のタッチが生きる。

The brushstrokes come to life.

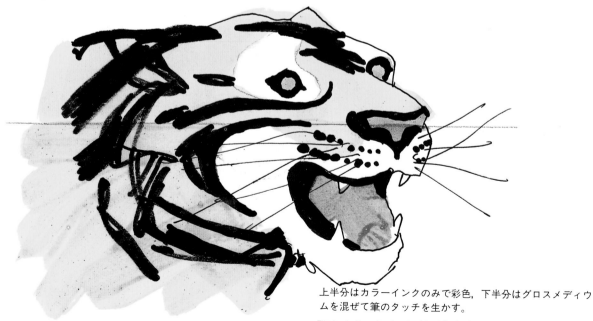

上半分はカラーインクのみで彩色，下半分はグロスメディウムを混ぜて筆のタッチを生かす。

The top half used only color ink while the bottom half used ink mixed with gloss medium to bring out the brushstrokes.

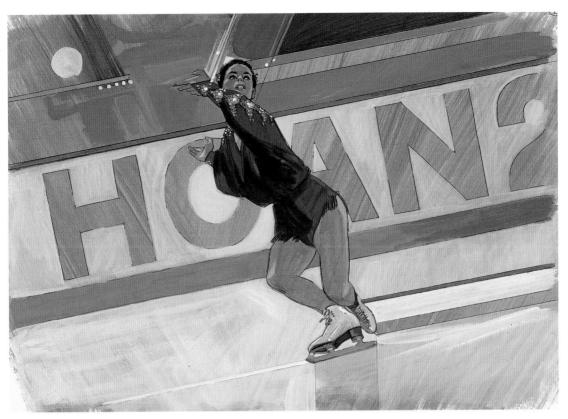

背景は筆のタッチを生かしスポーティな動きを表現するため
カラーインクにグロスメディウムを混ぜて彩色。ホワイトは
水彩絵具を使用。

The background uses the brushstrokes to bring out the sporty movement of the subject and so the ink was mixed with gloss medium before application. Watercolor white was also used.

ホワイトで描き起こす
Painting with White

1．ボディの基調色になるイエローを全体に塗る。

1.Cover the whole area with the base color of the body which in this case is yellow.

2．暖色のぼかし塗り。

2.Add a warm gradation.

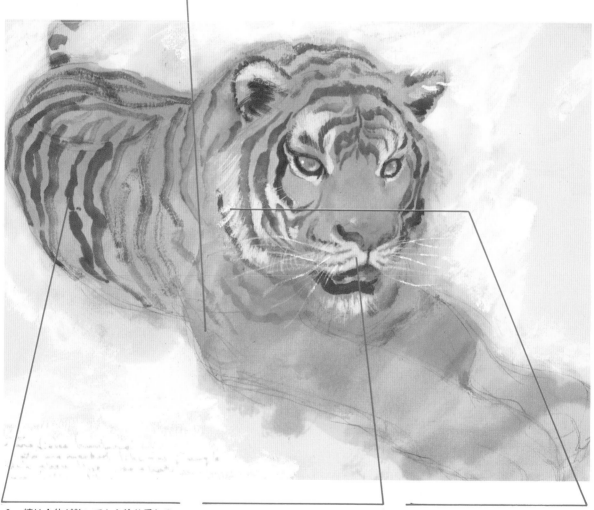

3．縞は全体が乾いてから塗り重ねる。水溶性のインクなのでボディの色とわずかに混ざる。

3.Wait until the base colors are quite dry before adding the stripes. The ink is water-based so the stripes will blend slightly with the body color.

4．薄く溶いたホワイトは下の色がわずかに透けて混ざってみえる。

4.Dilute the white so the base color can be seen through it slightly.

5．ホワイトを厚めにドライブラシして毛並みを表す。

5.Using white on a thickish brush, use the drybrush technique to produce the flow of the fur.

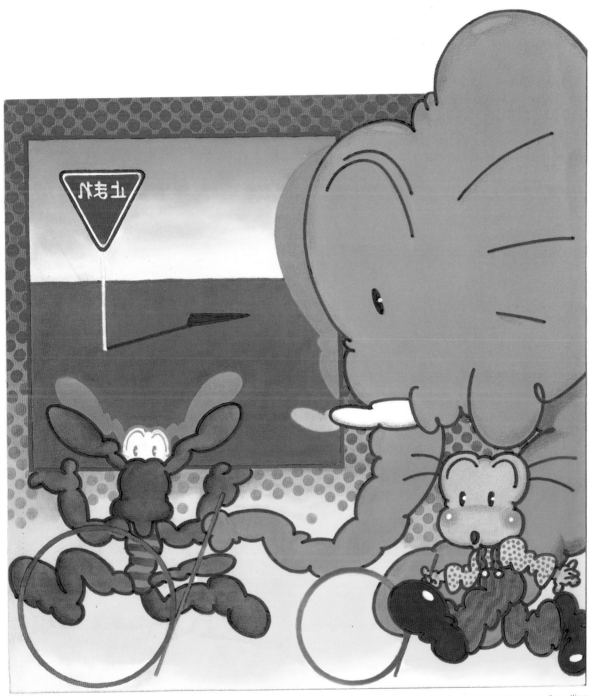

カラーインクで彩色してから，フェルトペンでグリーンの輪郭線を入れて個々のキャラクターを引き立て，鏡に移った像と表現を変えた。

After coloring with ink, a green felt-tip pen was used to go over the outlines of the characters to make them stand out and differ from their reflections in the mirror.

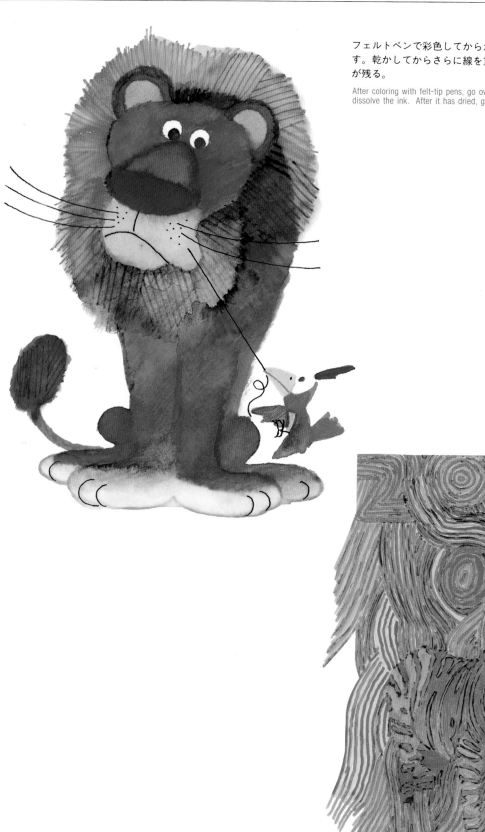

フェルトペンで彩色してから水を含ませた筆でこすって溶かす。乾かしてからさらに線を重ねてあっさりこするとタッチが残る。

After coloring with felt-tip pens, go over the surface with a wet brush to dissolve the ink. After it has dried, go over it again to produce strokes.

フェルトペンの中太の線を生かした彩色。

Coloring that makes the most of a medium sized felt-tip pen.

カラーフェルトペン
Colored Felt-tip Pens

水溶性フェルトペン
Water-soluble Felt-tip Pens

　フェルトペンは色数が豊富で先も細いのから太いものまであり，インクをつける手間が省け手軽に扱えるところがよい。水溶性のタイプは線描してから水を含ませた筆でこすると溶けて水彩風な効果が得られる。

Felt-tip pens come in a vast range of colors, there are a variety of sizes of tip from fine to broad and they save the trouble of applying ink so they are very useful. If the water-soluble type are used, the lines they produce can be gone over with a wet brush to create a watercolor effect.

フェルトペンの彩色(左)。水を含ませた筆でこすり色を溶かす（右）。
Color with a felt-tip pen (left).Go over the color with a wet brush to dissolve the ink (right).

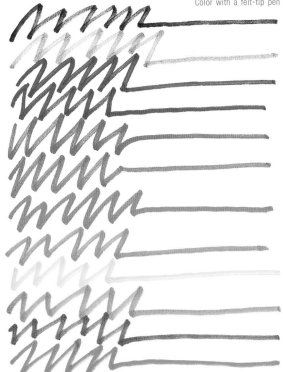

湿らせた用紙に点を打つとにじむ。
If dots are applied to a piece of moistened paper, they will run.

色数が豊富で太さもいろいろある。
They come in a variety of colors and sizes.

水彩絵具のホワイトは厚く塗れば完全に不透明になるが，薄く溶いて塗れば下の色が透ける。この性質を利用してカラーインクの上に塗り重ねて動物を描いてみよう。ここではガッシュを使用した。

If white watercolor paint is applied thickly, it is opaque, but a thin coat still allows the lower colors to be seen. Let us use of this characteristic by applying some animals over an area of colored ink. In this picture white gouache was used.

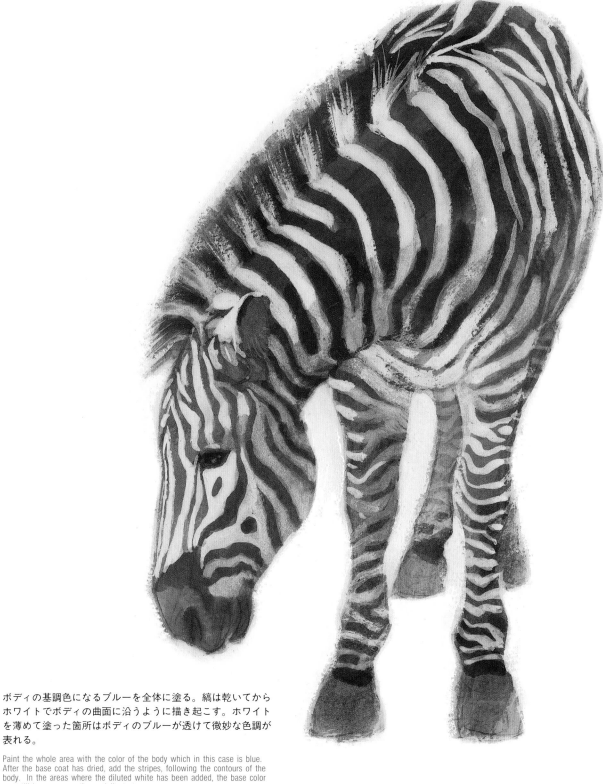

ボディの基調色になるブルーを全体に塗る。縞は乾いてからホワイトでボディの曲面に沿うように描き起こす。ホワイトを薄めて塗った箇所はボディのブルーが透けて微妙な色調が表れる。

Paint the whole area with the color of the body which in this case is blue. After the base coat has dried, add the stripes, following the contours of the body. In the areas where the diluted white has been added, the base color can still be seen, creating a delicate tone.

色数が豊富で細い線も太い線も引けるカラーフェルトペンは，インクをつける手間が省けるので手軽に彩色ができる。この利点を生かし，カラーインクで彩色してから線を入れたり，幅広いチップのマーカーを使って一気に彩色してみよう。

Felt-tip pens come in a variety of sizes and can produce both thick and thin lines. They save the bother of applying ink, making them very useful. After you have finished coloring in the orthodox way, use these characteristics to add lines or create thick strokes.

黒の油性のフェルトペンで輪郭線を入れてから，カラーインクで彩色。カラーインクが重なっても輪郭線がはっきり残る。

The outline was drawn using a black oil-based felt-tip pen then it was colored with ink. Even when the outline is covered by the ink, it remains quite clear.

チップの幅広いマーカーで一気に彩色した色面構成。チップのタッチは同じ色を何度も塗り重ねると消えてフラットな色面になる。

A design that was colored using a felt-tip pen with a broad tip. If the same area is gone over several times, the strokes of the tip will disappear, leaving an area of flat color.

低彩度色をつくる
Lowering the Color Saturation

鮮やかに発色するカラーインクは，単純に2色を混ぜても低彩度にならない。低彩度色にする色にイエローを混ぜ，さらに補色をわずかに混ぜることがポイント。

Color inks have brilliant colors and even if two colors are mixed, it will not lower the color saturation. To produce an ink with a low color saturation it is necessary to first add yellow then a small quantity of the complementary color.

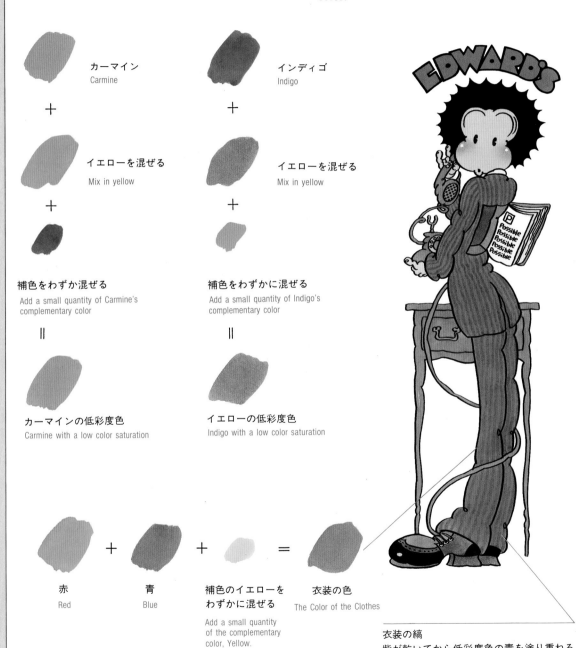

カーマイン
Carmine

+

イエローを混ぜる
Mix in yellow

+

補色をわずか混ぜる
Add a small quantity of Carmine's complementary color

=

カーマインの低彩度色
Carmine with a low color saturation

インディゴ
Indigo

+

イエローを混ぜる
Mix in yellow

+

補色をわずかに混ぜる
Add a small quantity of Indigo's complementary color

=

イエローの低彩度色
Indigo with a low color saturation

赤
Red

+

青
Blue

+

補色のイエローをわずかに混ぜる
Add a small quantity of the complementary color, Yellow.

=

衣装の色
The Color of the Clothes

衣装の縞
紫が乾いてから低彩度色の青を塗り重ねる

The stripes on the clothes
After the purple has dried, build up with a blue of low color saturation

4　章
表現と効果

Chapter 4
Expression and Effect

材質感の表現
Expressing Textures

材質感を表すには，光と影がつくりだす特徴的な部分を強調ぎみにとらえことがポイント。技法的にはペンのタッチとベタ塗りを効果的に生かすことがポイントになる。

The secret in expressing a feeling of texture is to exaggerate the areas that display a characteristic play of light and shade. With regard to technique, this is controlled by the way in which the lines and areas of color are applied.

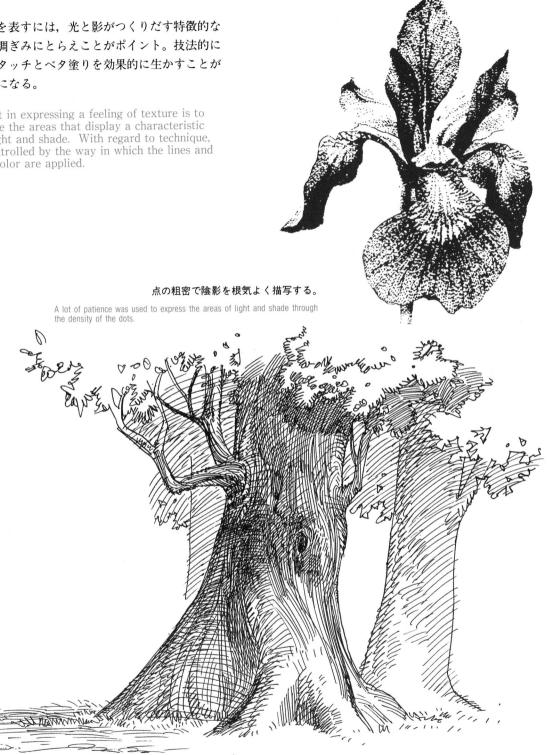

点の粗密で陰影を根気よく描写する。

A lot of patience was used to express the areas of light and shade through the density of the dots.

幹の凹凸に沿った線のタッチを強調する。

The shading is exaggerated to show the contours of the trunk.

86

ガラスの曲面に沿ったハイライトをシャープにとらえ，ベタ
塗りと対比させる。

The highlight in the glass is very sharp following the shape of the bottle and contrasting with the area of flat color.

革の滑らかさをベタ塗りし，光と影の微妙な凹凸をホワイト
で点描。金属質は明るくしてわずかにできる陰影部分を点描。

The smooth leather strap is expressed using flat color with the highlights added using dots in white. The metallic area is expressed in a light color with the small areas of shadow added through dots.

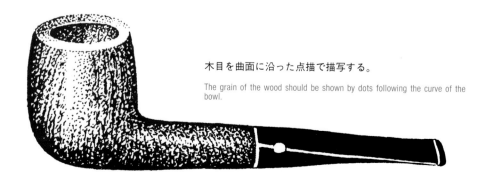

木目を曲面に沿った点描で描写する。

The grain of the wood should be shown by dots following the curve of the bowl.

省略する
Abbreviation

陰影を線のハッチングで表す。

The contours of the leaves were expressed through the density of the lines.

カゴの特徴的な網目を線描する。

The characteristic weaving of the basketwork has been expressed through lines.

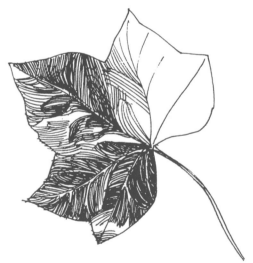

葉の凹凸を線の粗密で表す。

The shadow was expressed through hatching.

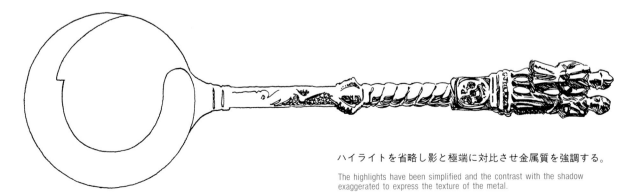

ハイライトを省略し影と極端に対比させ金属質を強調する。

The highlights have been simplified and the contrast with the shadow exaggerated to express the texture of the metal.

対象の大半を省略して，部分的な形の特徴をとらえることで材質感は強調される。これもペンのタッチ，つまり調子のない線で形を描写するか，点の粗密で調子をつくりだすことになる。

The texture can be stressed by abbreviating the subject and concentrating on the characteristics of certain areas. This can be done either through the strokes of the pen, that is to say, the shape of areas which have no shading, or through the density of dots expressing shading.

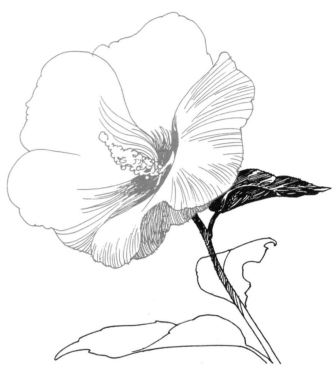

花弁と葉の曲面に沿ったハッチングを部分的に入れ，ほかは線描のみにする。

The curve of the leaves and petals have been expressed through hatching in certain areas while the rest is represented through lines.

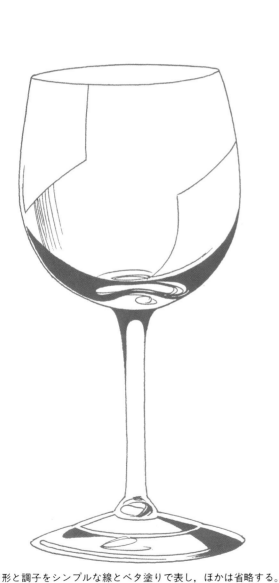

形と調子をシンプルな線とベタ塗りで表し，ほかは省略する。

The shape and shading have been expressed though simple lines and flat color. The rest has been abbreviated.

フラットな板を表すハッチングを陰の部分に入れる。

Hatching has been used in the areas of shadow to express the flatness of the wood.

黒の効果
The Effect of Black

　輪郭線の黒にたいしベタ塗りの黒は画面効果として別の意味をもつ。全体の雰囲気を支配することもあるし，画面を引き締める働きをすることもある。

Areas of flat black coloring have a different effect on the overall picture to the black of the outline. Sometimes it sets the mood for the whole picture while on other occasions it serves to draw the picture together.

高彩度色はさらに高彩度に見える。

A high color saturation appears even higher.

低明度色は高明度色に見える。

A low color value is transformed into a high color value.

黒と対比するとすべての色は引き立つ

The contrast of the black causes the other colors to stand out.

『悪夢』をテーマに黒の支配する世界を表現する　　　　　"Nightmare."　Expressing a world dominated by the color black.

群像を描く
Drawing a Crowd

人物がオーバーラップする群像は，下描きの段階で墨入れする線を明確にすることが大切である。墨線がしっかりしていれば，色が多少はみだしても不自然にならない。

When drawing a crowd of people where the figures overlap, it is important to make clear which lines are going to be added in black ink when making the original pencil sketch. As long as the black outlines are drawn clearly, it does not matter if the color spreads a little.

１．19世紀の出航風景をイメージした鉛筆のラフスケッチ。

1.A rough pencil sketch showing a nineteenth century scene of a ship preparing to leave harbor.

２．イメージスケッチにそって鉛筆で綿密に線描した下絵。

2.The original image sketch has been gone over again with a pencil, carefully filling in all the outlines.

３．下絵を部分的に描く。重なり合う群像の衣装を色分けす
るので，0.1ミリの製図ペンでしっかり墨入れする。

3.Draw the base picture in sections. The clothes of the people who overlap
will be differentiated through color so draw the outlines clearly using a 0 . 1
m/m. drafting pen.

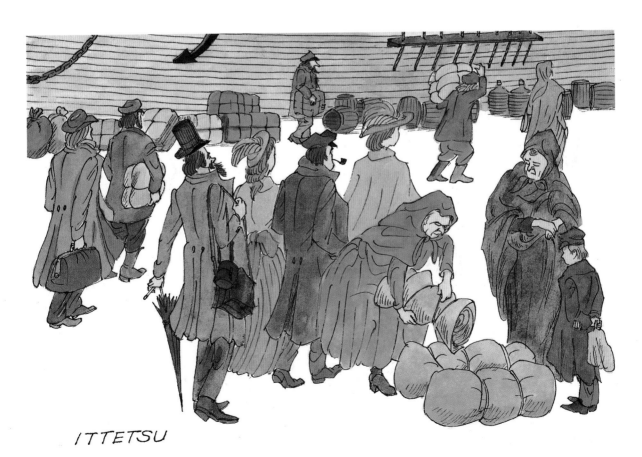

ITTETSU

４．古風な雰囲気を演出するため全体を渋い色調でまとめた。
衣装は部分的に重ね塗りして濃淡をつけた。襞をペンで線描
しているので濃淡のないフラットな彩色でもよい。

4.To give an impression of age, dark tones have been used overall. The
colors of the clothes have been built up in places to create shading. The
folds of the clothes have been drawn with pen lines so it is not necessary to
add tonal variety and a flat coat of color is adequate.

単純化
Simplification

　対象から受けるイメージを簡潔な線と色に置き換えシンプルな表現をしてみよう。細部描写にとらわれることなく，特徴的な形や色を残すことがポイントである。

Try expressing the image you receive from the subject through simple lines and colors. The secret is not to become too involved in details but to concentrate on the characteristic shape or colors.

ペンでリアルな描写。
A realistic pen sketch.

ペンのタッチを整理する。
Neaten the pen strokes.

特徴的な表情や動きをコミカルに表す。

The characteristic expression and movement
expressed in a comical way.

特徴的な体型とプロポーションの単純化。

A simplification of the characteristic shape and
proportions.

簡潔な線と色で表す。

Drawn with simple lines and color.

誇張
Exaggeration

部分的に誇張することで対象の特徴を一層強調して際立たせる表現方法がある。大きくしたり，小さくすることで，全体はアンバランスで不自然な形になるが，対象のキャラクターが明確に表現できる。

Another way of stressing the characteristics of the subject is through the exaggeration of various parts. The enlargement or reduction of various parts may make the subject look unnatural and unbalanced, but expresses its character clearly.

顔の一部を極端に大きくする
Enlarging Features of the Face

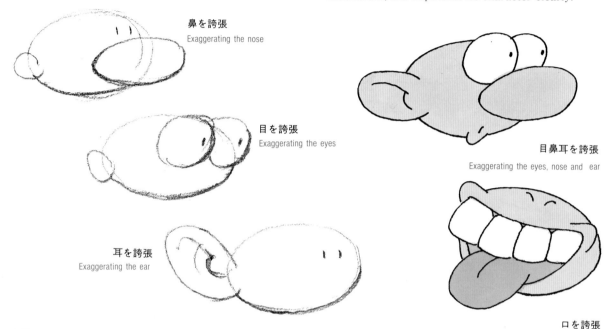

鼻を誇張
Exaggerating the nose

目を誇張
Exaggerating the eyes

目鼻耳を誇張
Exaggerating the eyes, nose and ear

耳を誇張
Exaggerating the ear

口を誇張
Exaggerating the mouth

顔を極端に大きくして誇張　　　Making the face extremely large

顔を大きく誇張
Exaggerating the Size of the Face

２等身のキャラクターにする

Make the head the same size as the body.

体型の誇張
Exaggerating the Shape of the Body

肘や膝の関節を誇張。

Exaggerate the knees or elbows.

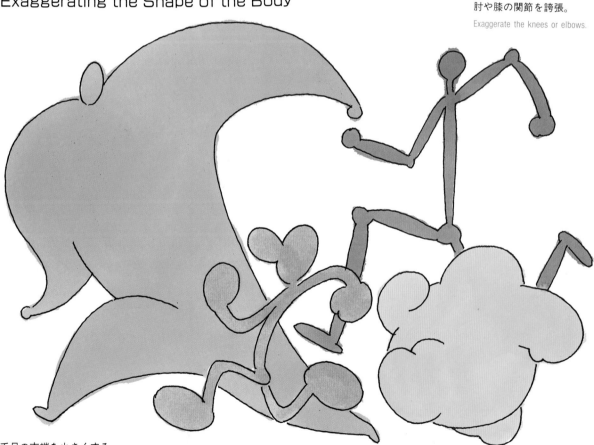

手足の末端を小さくする。

Make the hands or feet excessively small.

手足の末端を大きくする。

Make the hands or feet excessively large

全体を丸くふっくらさせる。

Make the whole body large and round.

キャラクターを動かす
Making the Subject Move

　誇張や単純化でキャラクターを明確にしたら，それにふさわしい動作を表現しなければならない。かわいらしさ，ひょうきんな感じなどそれぞれのイメージに合わせ動きもキャラクターを決定する要素である。

Once the features of the subject have been exaggerated or simplified to express its character, next it must perform suitable actions. The figures should behave in a cute or amusing way to match the image they make.

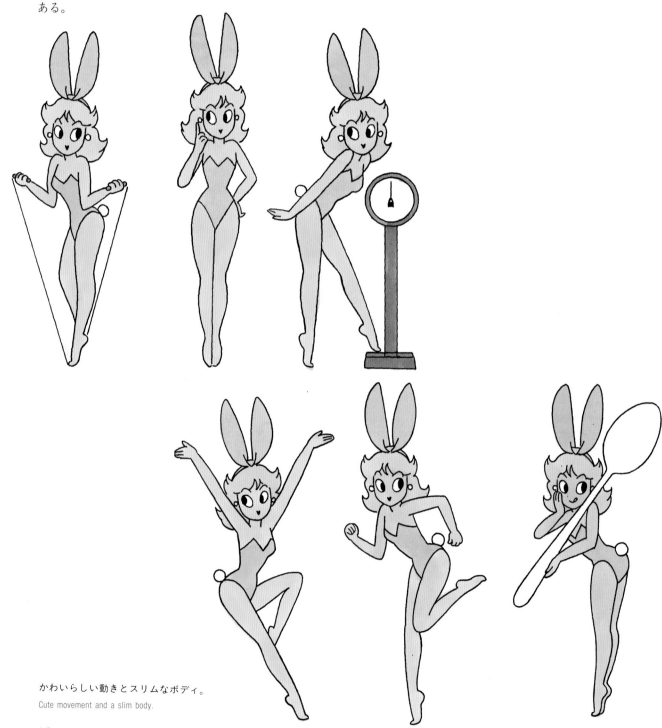

かわいらしい動きとスリムなボディ。

Cute movement and a slim body.

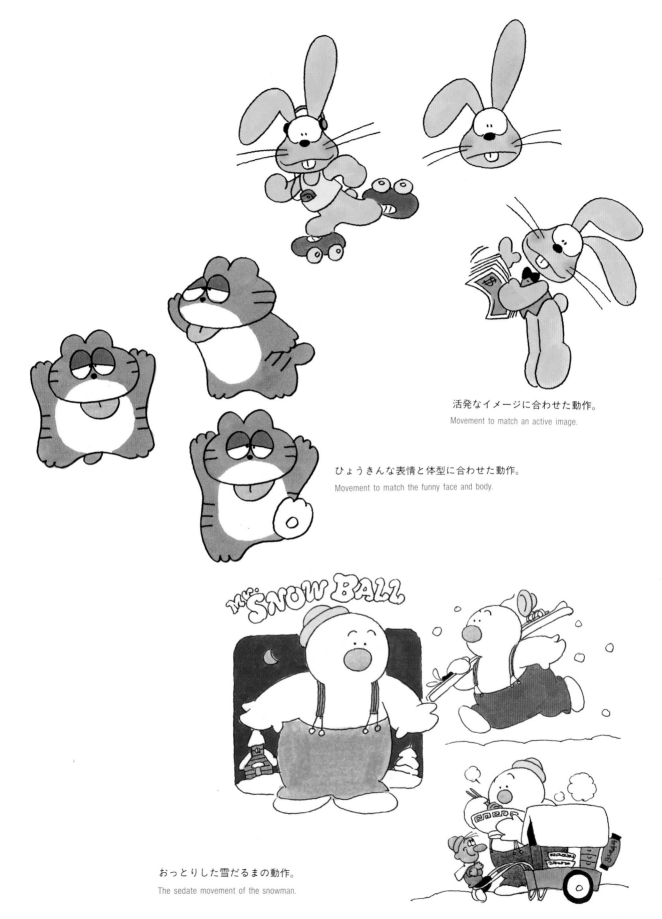

活発なイメージに合わせた動作。
Movement to match an active image.

ひょうきんな表情と体型に合わせた動作。
Movement to match the funny face and body.

おっとりした雪だるまの動作。
The sedate movement of the snowman.

コピー機を利用する
Using a Photocopier

　拡大縮小，変形，色の変換などコピー機はいろいろな機能が備わっている。1枚の原画を元にして手描きでは表現できないイラストレーションを制作してみよう。

Photocopiers have a variety of functions from enlargement and reduction to distortion or color substitution. A single picture may be altered to produce illustrations that would be impossible to create by hand.

カラーコピー機の色変換機能を利用
Utilizing the Color Substitution Function of a Color Photocopier

フェルトペン（黒）で描いた原画。
A picture drawn with a felt-tip pen (black).

黒を青に，余白をグリーンに変換。
Alter the black to blue and the white of the paper to green.

フェルトペンで彩色し，丸ペンで墨線を入れた原画。
A picture drawn using a round nib for the black lines and felt-tip pens for the coloring.

墨線を赤に変換。
Alter the black lines to red.

カラーフェルトペンで彩色した原画。

A picture that was colored using felt-tip pens.

ブルーをオレンジに変換。色の変換の幅を狭くすると原画の
色ムラがオレンジとブルーに分離する。

Alter the blue to orange. If the color substitution is set to narrow range,
the uneven color will separate into orange and blue.

変換の幅を広げるとブルーはオレンジにはっきり変わる。

If the color substitution range is set to wide, the blue will all change to
orange.

色変換と変形機能を利用
Utilizing the Color Substitution and Distortion Functions

写真を元にする。
Use a photograph as a base.

中間調をとばした白黒コピーにカラーインクで彩色する。
Make a monochrome copy without midtones then color.

カラーコピーでモザイク処理をする。
Use a color photocopier to create a mosaic effect.

定規を使って描いた原画。

A picture drawn using a ruler.

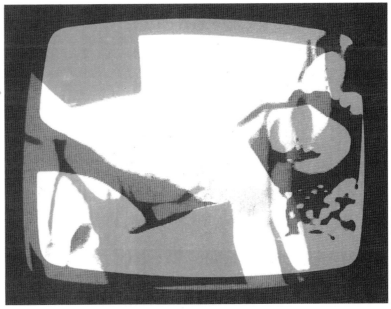

45度の斜体処理する。

Revolve through forty-five degrees.

部分的にイエロー，バックをブルーに変換する。

Change sections to yellow and substitute blue for the background.

赤に変換する。

Substitute red for the color.

黒のフェルトペンで描いた2枚の原画を透明なアクリルフィルムに青と赤に分けてコピーする。

Draw two pictures using a black felt-tip pen then use the photocopier to transfer them to transparent film, one in red and one in blue.

2枚をずらして重ねる。

Place on top of each other slightly out of register.

変形＆反復
Distortion and Repetition

ファックスして白黒反転。
Use a Fax to reverse the black and white.

製図ペンで描いた原画
A picture drawn using a drafting pen.

ファックスをコピーしカラーフェルトペンで彩色。
Make a copy of the fax and color with felt-tip pens.

手差し機能でコピーをずらし
オーバラップする。

Alter the degree of enlargement and
cause the pictures to overlap.

鏡面機能を使う。
Use the mirror function.

拡大率を変えてオーバラップする。
Use the manual feed to move the original and cause it to overlap

コピー中に原画を動かして変形させる。

Move the picture while it is being copied to create distortion.

長体機能で変形する。

Use the height function to cause distortion.

平体機能で変形する。

Use the width function to cause distortion.

原画を2枚描く。

Draw two pictures.

複数のコピーをとって切り貼りする。　　　Make multiple copies and paste them together.

拡大縮小

　ペンの線や点は，100パーセントの黒の濃度なので，微妙な中間調にとらわれないモノクロームのコピーに適している。線や点の粗密で表した調子は拡大すると迫力あるペンタッチとなって表れ，縮小すると密度が増して細密な表現効果となる。

Enlargement and Reduction

Lines and dots drawn with a pen have 100% contrast and as they do not contain half-tones they are very suitable for monochrome copies. The shading that is expressed through the density of lines or dots becomes very powerful when it is enlarged and when it is reduced, it becomes much finer and creates an impression of great detail

原寸
Actual Size

50パーセント縮小
50 Percent Reduction

150パーセント拡大
150 Percent Enlargement

200パーセント拡大
200 Percent Enlargement

スクリーントーンをつくる

　ペンのタッチでパターンを描きスクリーントーンをつくってみよう。パターンがある程度できたらコピーしてつなげばよい。ペンの線を生かしたイラストレーションの陰の調子や背景に貼り込んで表現効果を高めよう。

Making a Screen Tone

Try making a Screen Tone using a pattern drawn with a pen. After you have drawn a certain amount, you can make several copies and paste them together. Once it is complete it may be used for the shadow or shading in a pen drawing or for the background to improve an expression.

丸いパターンをつくる。

Make a round pattern.

四角いパターンをつくる。

Make a square pattern.

コピーした4枚を貼り合わせ連続パターンにする。

Make four copies of the pattern then paste them together to create a repeated pattern.

フリーハンドの直線パターンでつくったスクリーントーン。
A screen that was created from straight lines which were drawn freehand.

原画
Original.

透明なコピー用フィルムに複写して原画に重ねる。
Photocopy it onto transparent film and overlap the original.

おわりに

Afterword

　初めて手にしたペンは万年筆でした。高校時代はカラス口を使って製図を学んでいましたが，つけペンと墨汁を知り，ハヤシインクから発売された5～6色のカラーインクに心を弾ませたものです。これが柔らかい方向に進路を変えるきっかけになりました。当時はカラーインクの参考書もなく，失敗を重ねながら技法を習得したものです。本書で扱ったのはその集大成でもありますが，お役に立ったでしょうか。最後になりますが，小生の不備なところを補ってくれた成田一徹君，ありがとうございました。

The first pen I ever used was a fountain pen. When I was in senior high school I studied technical illustration using a drawing pen and that was the first time I used a dip pen and ink. I still remember being very excited when Hayashi ink brought out five or six different colored inks and this is what led to my branching out into lighter subjects. In those days there were no books available on using colored ink and I had to teach myself through trial and error. This book represents the sum of the things that I managed to learn and I hope that you will find it useful. Finally, I would like to say thank you to Ittetsu Narita for all his help in producing this book.

トリノまさる

本名：西丸式人

1945年生まれ。1972年東京芸術大学 V・D 大学院修了。

著書に『クロッキー教室』『水彩クロッキー』『クロッキー3人のモデル』『似顔絵の描き方』『絵画技法体系（共著）』。

『色鉛筆で描く』『淡彩スケッチ入門』グラフィック社がある。

Masaru Torino
Real name： Norito Saimaru
Born in 1945.
In 1972 he completed a postgraduate course in V.D. at the Tokyo National University of Fine Arts and Music.
Previous publications： "Sketching Classroom", "Watercolor Sketching", "Sketching with Three Models", "How to Paint Portraits," "Painting Technique Compendium" (joint work) as well as "Introduction to Colored Pencil Drawings" and "Introduction to Sketching in Watercolors" published by Graphic Sha.

成田一徹

1949年神戸市生まれ。

1976年大阪経済大学大学院修了。

酒場の情景を刻んだ切り絵をライフワークとして雑誌，書籍を中心に活躍。個展12回。

Ittetsu Narita
Born： Kobe 1949
1976： Completed a postgraduate course at Osaka University of Economics.
He specializes in producing paper cutouts depicting drinking scenes and has produced many works for magazines and books. He has held twelve exhibitions.

ペンとカラーインクで描く

1993年7月25日　初版第1刷発行

著　　者　　トリノまさる　成田一徹ⓒ
発 行 者　　久世利郎
印刷製本　　日本写真印刷株式会社
写　　植　　三和写真工芸株式会社
発 行 所　　株式会社グラフィック社
　　　　　　〒102　東京都千代田区九段北1-9-12
　　　　　　☎03(3263)4318　Fax.03(3263)5297
　　　　　　振替・東京3-114345
　　　　　　ISBN4-7661-0715-2 C2371